# PICTURING SCRIPTURE

Verse Art to Inspire the Biblical Imagination

*Picturing Scripture: Verse Art to Inspire the Biblical Imagination*

Copyright 2015 Kirkdale Press

Kirkdale Press, 1313 Commercial St., Bellingham, WA 98225
KirkdalePress.com

You may use brief quotations from this resource in presentations, articles, and books. For all other uses, please write Kirkdale Press for permission. Email us at permissions@kirkdalepress.com.

Unless otherwise noted, Scripture quotations are from the Lexham English Bible (LEB), copyright 2013 by Lexham Press. Lexham is a registered trademark of Faithlife Corporation.

ISBN 978-1-57-799680-4

Kirkdale Editorial Team: Rebecca Brant, Abigail Stocker
Cover Design and Typesetting: Jim LePage

Printed in China

# INTRODUCTION

As we read the Bible, its people and stories prompt a variety of responses as we reflect. We stand beside Adam in amazement at the menagerie of creatures God asks him to name. We marvel—and perhaps shudder—as we hear Ezekiel prophesy to the dry bones and watch them come to life. We sway in the boat on the Sea of Galilee and question whether we, like Peter, would have faith to step out onto the water to meet Jesus.

In this volume, you'll find the collaborative efforts of Christian artists and writers to capture their own responses to a hundred Bible verses, from Genesis to Revelation. Each passage evoked a visual representation, each image prompted a written reflection—each expression an act of worship.

As you turn through these pages, our prayer is that each pairing will prompt you to engage each Scripture from a fresh perspective—one that leads you, too, to celebrate the Author of this inspiring book.

## GENESIS 1:1

---

This is one of those verses we hear all the time. God made everything. It's an amazing feat, and I don't think we take it lightly. After all, everything is everything. He created heaven and earth, land and sea, sun and moon, bird and fish, beast and human, man and woman.

That's a big deal, but I think there's an even bigger point we can lose sight of. It's amazing that God made everything. It's unthinkable that God made *anything*.

Before the beginning, God was it. Nothing else. To exist was to be divine because only the divine existed.

By making anything—anything at all—God shared part of what made him God. Yes, he made the world and shared it with us. But before that, God shared existence itself.

—*Jeffrey Kranz*

IN THE BEGINNING,
GOD CREATED THE HEAVENS
AND THE EARTH.

Genesis 1:1

## GENESIS 35:10

There are so many days I wish I could leave behind my old name, the bad decisions I've made, and all the foolishness I'm known for. Names have so much history to them. As we make choices in life, they become attached to our name and how people know us. We trade on our reputations and (especially when we're job-hunting) our friends' good names.

Jacob was a liar and a cheat. He'd broken family ties and hurt loved ones. What must it have meant to him to be given a new name, one that wasn't associated with any of his past sins?

That's exactly what salvation in Christ does for us. As sinners in need of a savior, we could never do anything to deserve God's favor. Yet he sent his son to pay the penalty for our sins—to die for us. We've been given new identities in Christ Jesus, just as Jacob faded away and gave rise to the nation of Israel.

—Jessi Strong

# ISRAEL

J    A    C    O    B

And God said to him, "Your name is Jacob; no longer shall your name be called Jacob, but Israel shall be your name."

So he called his name Israel.

**GENESIS 35:10**

## 1 KINGS 3:9

If you were to hold this book to your nose, what would you think of these words? As they blur, multiply, and blend into one another, perhaps you'd discern a phrase or two, or maybe even string together a complete sentence. You'd probably develop methods to understand what you see—closing one eye, then the other, or focusing on a mottled mass of ink until it morphs into something legible.

Of course, the only sure technique would be to move the book away until the hazy figures come into focus and you can read the page from beginning to end.

Solomon was so close to the challenge of ruling God's people that he couldn't make sense of it. So he asked the one who sees the whole picture to give him wisdom to tell right from wrong. We can pray for God's wisdom too, asking him to give us his perspective on the challenges that crowd so closely that they can blur the line between good and evil.

—*Tyler Smith*

# GOOD

*Give your servant therefore an understanding mind to govern your people, that I may discern between good and evil, for who is able to govern this your great people? —1 Kings 3:9*

# 1 CHRONICLES 16:34

God chose Israel. God made promises. God followed through on every one.

How could they not thank him?

God triumphed over Pharaoh. God bested all the idols of Egypt, Moab, Heshbon, Bashan, and Canaan. God made Israel his own and defended them. How could they not thank him?

God made the heavens and the earth. God rules the universe in righteousness. And yet, he chose to dwell among his people. How could they not thank him?

And his loving-kindness endures forever—even now. His mercies are new every morning (Lam 3:22–23). The same loving-kindness that made Asaph sing these words is as alive and active and new today as it was then. How can we not thank him?

—*Jeffrey Kranz*

OH GIVE THANKS TO THE LORD,
FOR HE IS GOOD; FOR HIS STEADFAST LOVE

ENDURES FOREVER

1 CHRONICLES 16:34

# NEHEMIAH 9:6

---

I was an astronaut between the ages of 6 and 9. I converted blankets into silica/aluminum wings and stuffed the couch with food from the pantry so that I wouldn't run out on my long trips. I always loved the moons orbiting Jupiter, and the nebulous, swirling clouds forming new stars, and the dying white dwarfs many light-years away.

Much of what we know and enjoy about outer space today was surely unimaginable to the ancient Jewish world—but Nehemiah seems to get it. God made it all, and it all worships him. Even if we can't see it or imagine it, it exists for God's own glory. It's an unimaginable display of beauty, strength, power, and immensity. The still-popular medieval notion of heaven—of clouds and blue skies and flying angel babies—is, for me, a poor imagining of the splendor of heaven that Nehemiah says worships its Creator. If the mysteries of life in the depths of the ocean and the unknown vastness of faraway galaxies teach us anything, it's that God creates things for himself—and he preserves them even when no one else can see.

—*Brandon Rappuhn*

YOU ARE THE LORD, YOU ALONE. YOU HAVE MADE HEAVEN,

# THE HEAVEN OF HEAVENS,

WITH ALL THEIR HOST, THE EARTH AND ALL THAT IS ON IT,

NEHEMIAH
9 : 6

THE SEAS AND ALL THAT IS IN THEM; AND

# YOU PRESERVE ALL OF THEM;

AND THE HOST OF HEAVEN WORSHIPS YOU.

## PSALM 8:1

When at our most vulnerable, we might look at the stars and think about how small the Earth really is. We're just a tiny speck of dust amid billions of stars. Unrelenting, powerful forces of nature speed us along in a chaotic dance through the cosmos.

So we turn to science and technology to make sense of the universe. Yet, in the end, science and technology fail us. When our ingenuity, our collective knowledge, and the technology we rely on fail us, what else can we turn to?

The Creator of everything.

It's not science or technology that connects us across time and space. Instead, it's a deep, sacrificial love that conquers all things. His glory and majesty is written among the stars. Turn to him, and know that even the tiniest speck of dust matters to him.

—*Jake Mailhot*

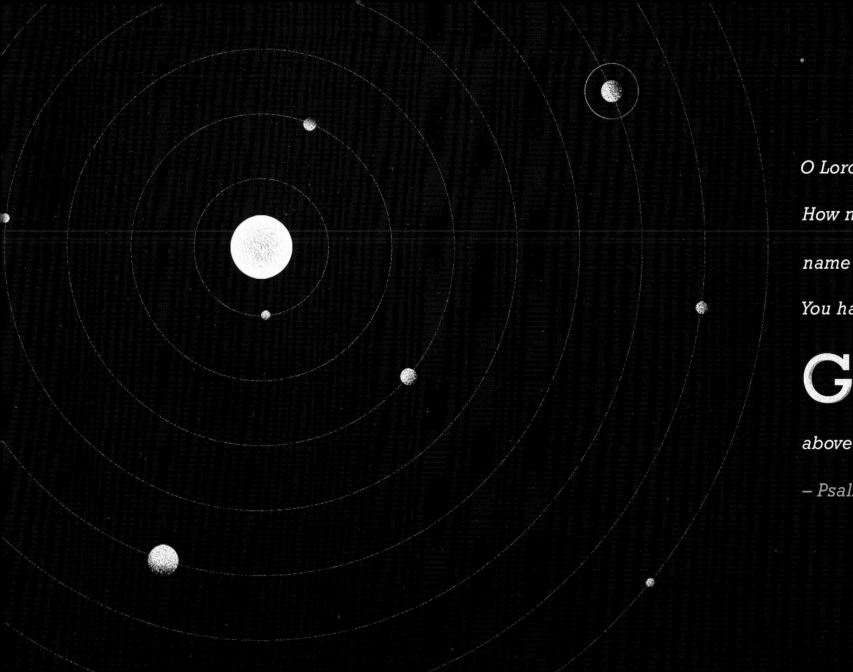

*O Lord, our Lord,*

*How majestic is your*

*name in all the earth!*

*You have set your*

# GLORY

*above the heavens.*

*– Psalm 8:1*

## PSALM 9:1

I often refer to myself as a realist, someone who can see the hard side of life and detect ulterior motives. I can find negativity and voice complaint with little effort or prompting.

How easy is it to see the sin and suffering that pervades life—my life and the lives of those around me. My actions are a poor witness to God's work. It's difficult to see beauty, goodness, and grace—the things that originate with God and are present in the way he is transforming me and others. I'm barely aware of his work sometimes, but in reality, his deeds are beyond number.

Living a life of lax introspection isn't part of my calling as a follower of Christ. I need to be someone who sees God's grace and goodness and thanks him for it. I need to be one who tells others of his work and who lives as a representative of his grace. It's not a positive spin on bad circumstances. It's real hope that God can transform even the most dire life circumstances.

—*Rebecca Van Noord*

I WILL GIVE THANKS TO THE LORD WITH MY WHOLE HEART;

007,536,290

I WILL RECOUNT ALL OF YOUR WONDERFUL DEEDS.

PSALM 9:1

## PSALM 22:11

We live in a world that is difficult and frightening at times. Sometimes the painful situations seem unending. When I am in the middle of times like this, fear quickly sets in. It's easy to feel out of control and start to doubt when nothing seems to make sense. I feel tempted to look for help from people or books. I run around trying to fix something that I have no control over. I let my problems overtake me because I become weary and tired. This is when I remind myself that my situation is temporary, but God is eternal. He is bigger than any problem I might be facing. My strength isn't enough to get me through. I need to ask God to be near.

My scariest day took place last year, when our daughter had a very serious emergency surgery. I felt like my whole world was crashing in on me. I could barely muster enough faith to even pray. But my feeble whisper, "Rescue us, God," was enough. He heard me, and he answered my prayer. He met us right where we were. Although we felt terrified, we felt his peace.

When you feel overwhelmed by a tough situation and help is nowhere in sight, ask God to help you. Even though people will fail you, he never will. When you don't have the energy to keep fighting, he will keep you safe. And he will bring peace even in most violent storm.

—Michelle Lindsey

# BE NOT

## *far from me,*

### FOR TROUBLE IS NEAR,
### AND THERE IS NONE TO HELP.

◆ PSALM 22:11 ◆

# PSALM 23:4

———

Have you ever felt hopeless? Even the most sanguine individuals can fall into despair. Whatever the cause—the death of a loved one, divorce, sickness, debt, depression—it can feel like a deep pit, enveloping you in darkness.

I love hiking, so when I read this verse, the analogy seems obvious. Any avid hiker can tell you the most rewarding trails are the most difficult. With game trails and other paths constantly branching off, it's easy to get lost. Long and steep, these trails are littered with distractions, switchbacks, roots, and stones.

God promises to protect me from such stumbling blocks. He wants to illuminate my darkest places and, like a pillar of fire, show me the path forward. He will guide me every step of the journey, from the valley of despair to the peaks of joy and restoration. Once I leave hopelessness behind, his grace and love are more uplifting than the most breathtaking view of mountain peaks or alpine flowers.

—Abby Salinger

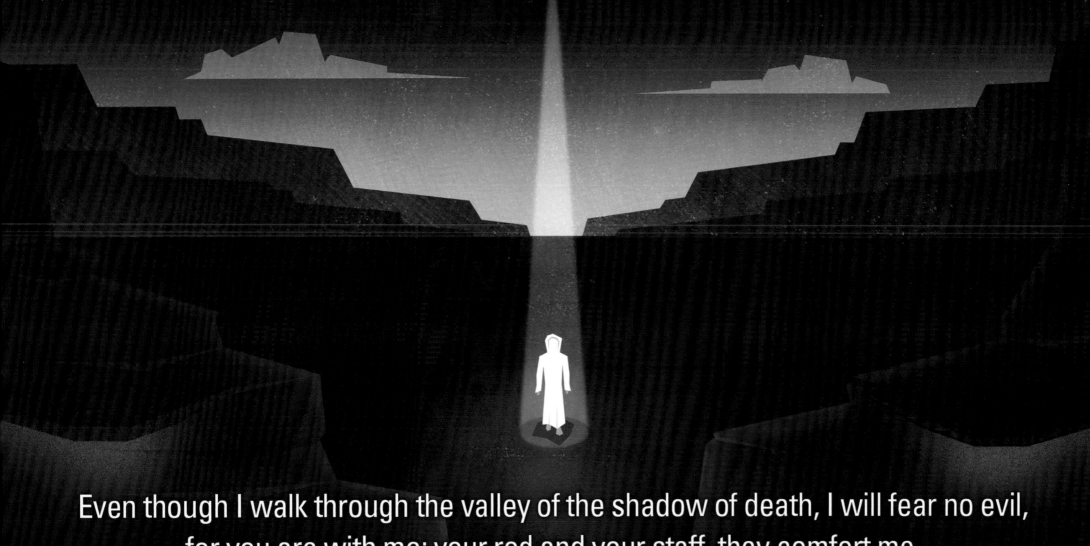

Even though I walk through the valley of the shadow of death, I will fear no evil, for you are with me; your rod and your staff, they comfort me.

**PSALM 23:4**

## PSALM 25:4

When we're young—maybe even when we're older—our parents tell us what to do. We may resent their rules and restrictions, but obeying them can save us from making mistakes when we face choices we're not yet wise enough to make for ourselves. We learn many lessons from obedience and disobedience alike as we journey to autonomy.

God has given us the ability to choose any path we like—and we have far more avenues available to us than our parents and the generations before them. Our lives hold even more ways for us to serve him, but they also bring a greater array of temptations. God knows we are free to choose a path that might lead us away from him.

But as a good and loving Father, he also gave us his Word so we could learn to choose wisely and to follow him. By spending time in Scripture and in prayer, we grow to understand his ways and how to make the choices to live a life that is pleasing to him.

Instead of looking for detours around the rules, remember our Heavenly Father's love—and respect his desire to guide our lives in his wisdom.

*—Rebecca Brant*

Make me
to know your
ways, O LORD;

# TEACH ME YOUR PATHS.

PSALM 25:4

## PSALM 25:5

We grow up looking to others for authority. It isn't until we get older that we become more independent and think we know what's best. I can be so stubborn that I hang onto an idea, even when I realize there's a better solution. It can be hard to listen and take direction—it's not our first instinct. We need to be intentional about slowing down, listening, and truly understanding how to turn to God when we lose our way.

Being still seems like it should be so easy. You're not actually doing anything, so what's the big deal? But being still is an active response to God's call. We lean in his direction. We have to be still and listen before we can understand his leading and teaching. When we slow down and refocus on God's authority, he guides our lives and proves that relying on and waiting for his direction is worth the effort of being still.

—*Pam Bauthues*

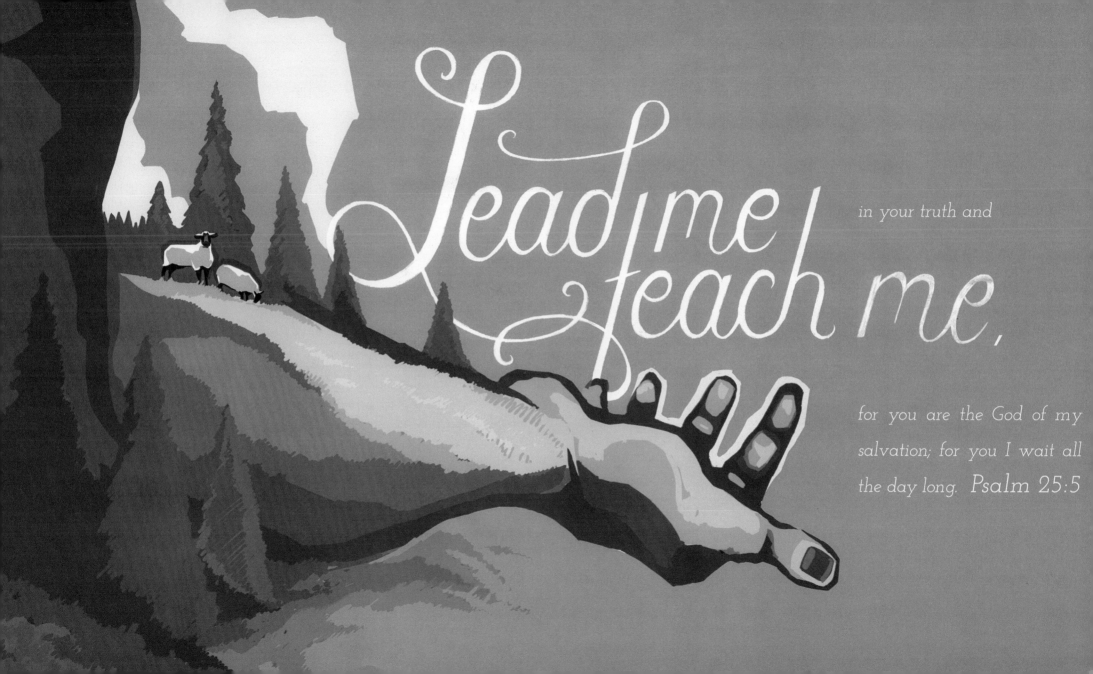

Lead me teach me, in your truth and for you are the God of my salvation; for you I wait all the day long. Psalm 25:5

## PSALM 33:20

———

Colorado's Rocky Mountains will always be my home. Although I've since moved to a different stretch of Rockies, I've lived most of my days in my home state with a view of those rugged peaks, more than 50 of them rising 14,000 feet into the sky—beautiful and snowcapped year-round. They made me feel safe, protected, and I had only to turn and look for them to know which direction I was headed. If only I had explored them more.

For me those mountains stand as testament to God's steadfast love—faithful, immovable, a comfort and shield for those who look to him in faith.

Do you find God's character reflected in his creation? What can we learn of his nature from the oceans, the forests, the deserts and jungles? I want only to explore him more.

—*Rebecca Brant*

*Our soul waits for the LORD; He is our help & our shield.*

Psalm 33:20

## PSALM 34:8

It's easy to feel down when things don't go how we hoped. Our natural tendency is to be angry at God when unexpected trials come our way. But we're called to take refuge in him no matter what—a scary diagnosis, a dream crushed, a heartbreaking loss, a plan fallen through.

He is the definition of trustworthy. After all, he's pieced together our lives in the most perfect way possible. We're part of a grand plan, and that's something to be joyful about. We will face trials of all kinds, but we can choose to rest in the joy and hope that come with the blessings God gives. Taste and see that he is so good!

—*Tayler Beede*

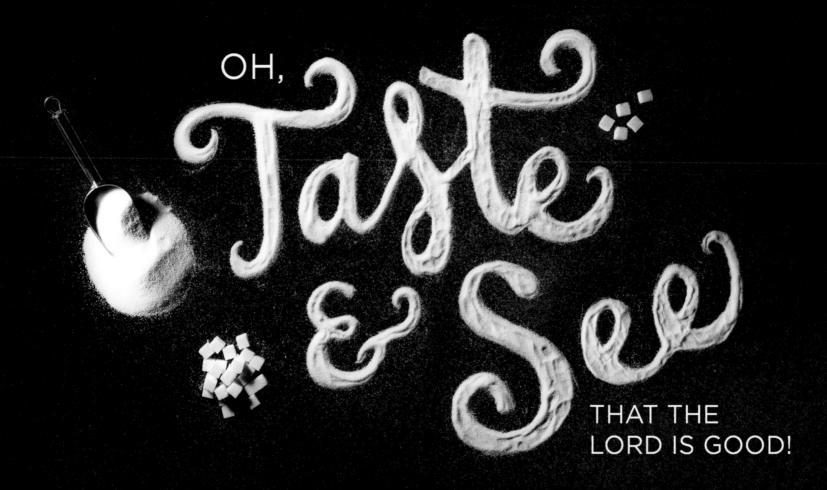

OH, Taste & See THAT THE LORD IS GOOD!

BLESSED IS THE MAN WHO TAKES REFUGE IN HIM!

PSALM 34:8

# PSALM 37:4

Just take a second to connect the imagery here to verse. The larger heart represents the fullness of your heart. Now think of the little heart as God's love for you. Without his love, your heart just isn't complete.

As humans, we're innately filled with desires. If I take delight in the Lord, he will give me the desires of my heart. If I do not take delight in the Lord, I am leaving those desires up to chance. I am basically saying, "God, I can do it myself. Watch me."

It's easy to get caught up in that, too. Without even really thinking about it, I find myself going through life doing things by myself, for myself. Not because I think I can do it better than God can, but simply because things are going well so it seems as if I can do it on my own.

That's when I take a step back, reread this verse, and reflect on how I will never achieve the desires of my heart on my own—I must delight myself in the Lord.

—*Lauren Visser*

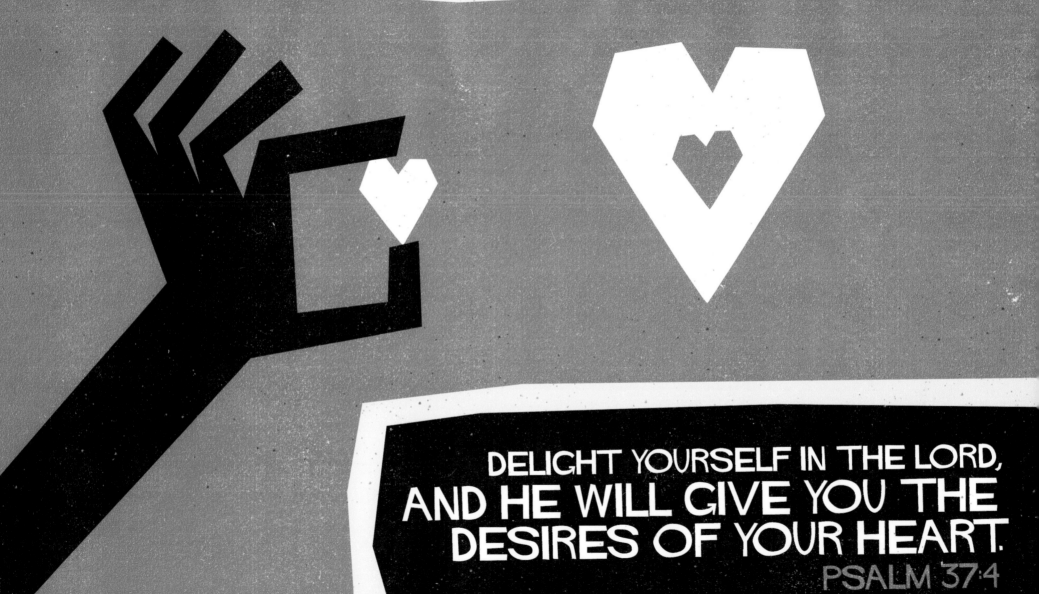

DELIGHT YOURSELF IN THE LORD, AND HE WILL GIVE YOU THE DESIRES OF YOUR HEART.

PSALM 37:4

## PSALM 46:10

Be still: These words in Scripture call to mind Jesus' authority over the wind and waves. They're an echo of an Old Testament promise that the Lord will fight on behalf of the Israelites. In our busy, smartphone-dominated culture, I've found that stillness does not come easily to me. I surf the internet while watching television, check my phone while riding the bus, and catch up on podcasts while working around the house. When I'm not multitasking to maximize my productivity, I'm doing so to stave off boredom. Either way, stillness eludes me.

Psalm 46:10 reminds me that what matters in the world is not what I can accomplish. The Lord promises here that *he* will act. He will be exalted, and while he desires our service, he doesn't need our efforts to gain glory. Being still means trusting that God will do what he says he will do.

—*Jessi Strong*

PSALM 46:10

# be still
## and know that I am God

I will be exalted among the nations, I will be exalted in the earth!

# PSALM 51:10

———

It's easy to say—or sing—Psalm 51 without personal sacrifice. Its words echo in innumerable songs of praise as we ask Christ to transform us. But for me, the words of this psalm will always be linked to the liturgy. I sang "Create in Me" every Sunday after the offering in the various rural Lutheran churches I attended growing up.

After passing the offering plate, the liturgy reminded us that surrendering our earthly possessions to God was only the start of the process. Even King David needed to surrender. After great personal loss, he could have acted in pride to save face in the eyes of the world. But surrendering his future was the necessary foundation for David to start fresh and rebuild his relationship with God.

Just as we cannot become a part of the body of Christ without giving up our claims to exclusive knowledge of God, our hearts aren't purified in a vacuum. But when we give of ourselves, God is able to use our lives for his glory—and watch the ripples of his love spread from a single heart into the world.

—Abigail Stocker

# Create in me a clean heart, O God,

**and renew a right spirit within me.**

PSALM 51:10

## PSALM 51:17

———

When my siblings and I fought as children, resolution often came only when our mother forced us to apologize to each other. When I felt particularly defensive and sure of my right-ness, it seemed like a great insult to make nice with an undeserving party. I did my best to say the words while showing in my tone and body language that I was anything but sorry. My actions rendered my words meaningless.

The Israelites often followed the rituals prescribed in the law while keeping their hearts far from God. The letter of the law called for sacrifices to atone for sin, but God isn't interested merely in ritual. The sacrifice that is not accompanied by a sincere heart is worthless to him.

Although we no longer bring physical sacrifices to atone for our sin, God is no less concerned with the state of our hearts. He is pleased when we come humbly to him in repentance.

—Jessi Strong

THE SACRIFICES OF GOD    ARE A BROKEN SPIRIT;

A BROKEN AND CONTRITE HEART,    O GOD, YOU WILL NOT DESPISE.

PSALM    51:17

# PSALM 52:8

---

An olive tree can live for centuries and flourish even in harsh conditions. The psalmist seems a tad overconfident in his declaration, but his trust in God gives him reason to feel strong and deeply rooted.

I could trust in a lot of things—the security of my job, my marriage, my 401K plan, my busy and seemingly important life. But none of these good things are ultimately The Good Thing that will make me thrive. God's "steadfast love" is the quality that inspires the psalmist. Likewise, it's my rootedness in him because of his steadfast love—demonstrated through Jesus' sacrifice—that will help me thrive in any state.

So go be like an olive tree: Prosper in crazy harsh conditions. Be stable when winds whip you and scorching sun burns you. You'll withstand it all because he's got this.

—Rebecca Van Noord

BUT I AM LIKE A
# GREEN OLIVE TREE
IN THE HOUSE
OF
GOD.

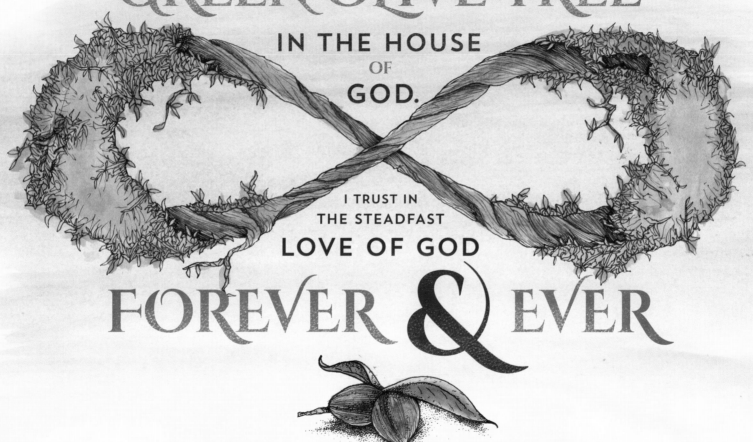

I TRUST IN
THE STEADFAST
LOVE OF GOD

# FOREVER & EVER

PSALM 52:8

# PSALM 65:3

When all of my children were little, they loved to play in the mud. No matter how many times I instructed them to steer clear of those puddles, they jumped in anyway. Puddles were irresistible.

The longer their muddy misadventures went unchecked, the dirtier they got. Sometimes they were so caked with dirt and muck, they not only needed a bath—they needed new outfits. We had to dispose of their clothes because they were beyond cleaning.

Sin is a lot like those mud puddles. Even though our conscience may tell us to steer clear, the allure of sin can have an overwhelming pull on us. Like children playing in a puddle, we get dirty from head to toe, with a crust of filth upon us.

Far stronger than any worldly soap, the blood of Jesus washes away our sins and transgressions. Made spotless in our heavenly Father's eyes, we will one day stand before him clothed in robes of white (Rev 7:9).

—Shaun Tabatt

When iniquities prevail against me, you

# ATONE

for our transgressions.   Psalm 65:3

## PSALM 90:12

———

Patience isn't always my strong suit. I want to have all the things done, yesterday. I'm an expert list-maker, and I gain far too much satisfaction from numbering my tasks, checking them off, and drawing up tidy lists of my accomplishments.

But I've come to realize that God isn't looking for the perfect resume of my life. What, then, is a wise approach to living? As Chris Rice sings the words of Psalm 90, "Teach us to count our days; teach us to make our days count."

The accomplishments that the world numbers as valuable are unending—I'll never be able to complete them all. But this psalm reminds me that it is good to be mindful of how I'm spending my life. Wisdom is knowing which things matter—and pursuing those truer things with all of my time. It's being open to having my priorities changed, to having God teach me how to number those things that shape and form my heart.

—*Abigail Stocker*

SO TEACH US TO NUMBER OUR DAYS
THAT WE MAY GET
A HEART OF WISDOM.

PSALM
90:12

## PSALM 91:8-9

———

When I was in third grade my family moved, then in fifth we moved again, and in eighth we moved again, and again, and again … by the time I was 16 we had moved more than 10 times. As I grew older I found it more challenging to make friends. I listened to lies telling me, "You aren't good enough, you need to do this to be cool, or that to have friends…"

For a time, I believed these lies. I wasn't relying on God, I hadn't made him my dwelling place, and I didn't seek after him to be my refuge; instead I immersed myself in a world of wickedness. God's saving grace pulled me out of the weeds. This is where I began to understand God's incredible love.

Trusting in God can be scary. We want to plan our lives and be in control. We want to know what is going to happen next or why something hasn't happened the way we wanted it to. This is when we need to take a step back, breathe a prayer of trust, and rely on God to be our refuge in times of trial.

—*Katie Monsma*

You will only look with your eyes and see the recompense of the wicked.

Because you have made the LORD
your dwelling place—the Most High,

# WHO IS MY REFUGE

## PSALM 96:2-3

This verse paints a beautiful picture of thankfulness for God's all-encompassing love.

God loves us no matter our differences and despite our shortcomings. He looks at us and says, "You are an amazing and beautiful creation." No matter what we say or what we do, he will shower his love on us. His incredible faithfulness draws me back to his love time and time again.

I often find it difficult to take time to truly praise God for all the love he has lavished on me. I find myself taking time to ask for wisdom, for patience, for financial stability ... you name it, I've probably spent time asking God for it. But taking time to praise and adore God is essential and should be a daily habit.

Thankfully we have his Word to remind of his faithfulness and to encourage us to "tell of his salvation from day to day."

—*Katie Monsma*

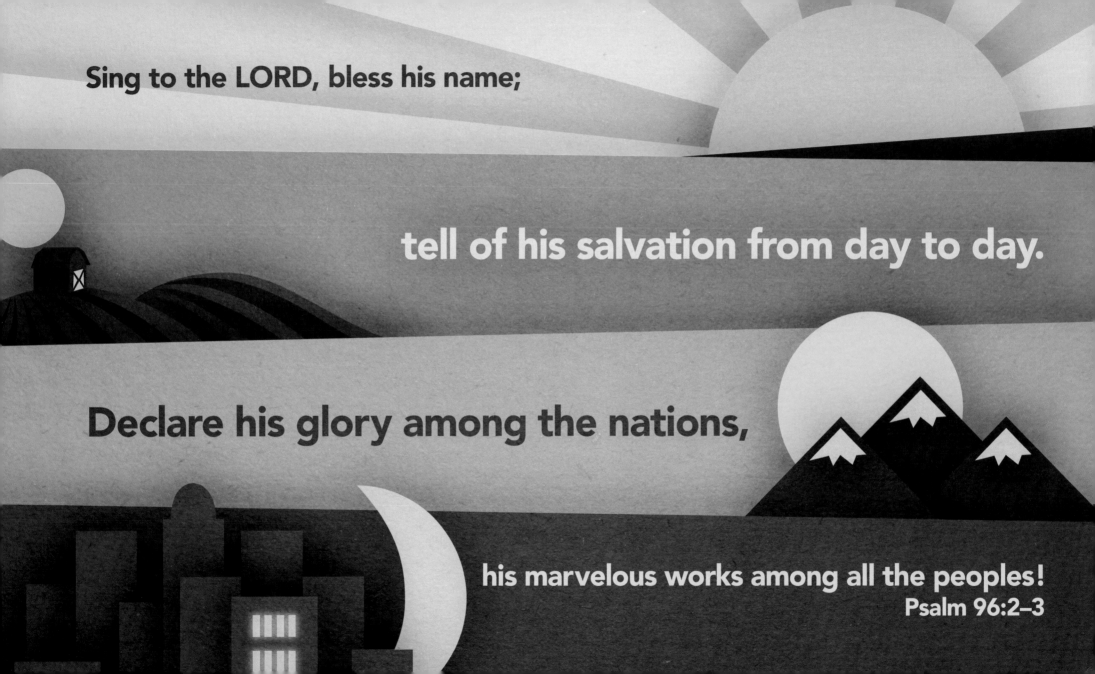

## PSALM 103:2

———

The benefits package I have through work covers dental. I'm actually pretty excited to get some dental work done in a few weeks—work that will fix some mistakes that were made nearly 13 years ago. Most people crumble under the sounds of the drill and the needle, but for me, these are sounds of long-desired repair.

But I have a different benefits package from my employ to God and his kingdom. God's benefits cover my soul—something mortal men can't even touch. Unlike my teeth, my soul can't be repaired by human doctors from the stains of sin. For these, Jesus is my doctor.

Bless the Lord, O my soul. The wear and wounds of the years have damaged me beyond my knowing. May I never forget to call on my Physician and rely upon the assurances of God, my eternal provider.

—*Brandon Rappuhn*

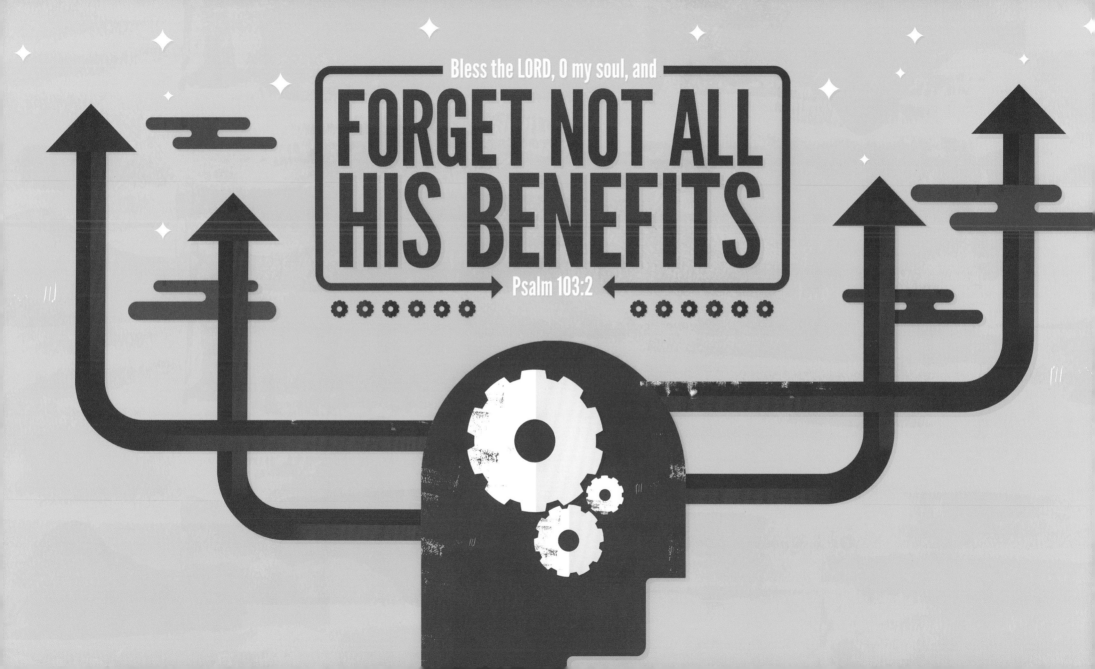

## PSALM 104:19

The closer I stay to the rhythms of God's created earth, the more human I feel. I need the anchor of tide and seasons, sun and moon in this world of technological arrogance—with its hurry and unlimited options. I need reminders that I am not at the center of the universe.

When I pause to watch the sun go down, I am less tempted to stay up wasting time on my computer—and I wake to see the sunrise. With the moon, I come and go, say yes and no, discern the line between needs and wants, and relinquish my addiction to achievement. My own discontent fades in the rhythms of spring, summer, fall, and winter—their newness and joys. How easy it is to forget the earth—and the Creator—with 24-hour purchasing power, high-speed (but not intimate) connection, and year-round tomatoes.

Can I take my cues from the earth, finding courage to let myself wax and wane, sleep and wake, rest and work, grow and bury, grieve and rejoice, sprout new leaves and shed them?

—*Carrie Sinclair Wolcott*

He made the moon to mark the seasons;

the sun knows its time for setting.

Psalm 104:19

## PSALM 118:8

How many times have you heard someone say, "Trust me"? Too often our promises are based on things beyond our control. The wiser we get, the more we realize how little we really know—and the fewer promises we make. But God knows everything, even the future. We will always be better off leaning on the one true God than trusting in the people he created. Even if they're wiser, wealthier, and more powerful than we are, they can never promise or provide us more than God does.

I desperately want to depend on God in all areas of my life, but when I don't know what he's up to, it can be hard to live like he has everything under control. Make no mistake—taking refuge in the Lord isn't necessarily the comfortable choice. His will might not look like the better choice from our limited perspective, but we know from his Word that trusting God is always for the best.

—Ryan Nelson

IT IS
BETTER TO
TAKE REFUGE IN THE
LORD
THAN TO TRUST IN MAN

PSALM 118:8

## PSALM 119:176

It pains me to admit it, but I haven't been to church in a while. And surprisingly to me, the lapse came about with unsettling ease. All it took was a derailing life event and genuine concern from my community. It wasn't their fault; some questions are just too painful to answer.

It wasn't always this way. I used to be as committed as they come. I counseled and mentored, I preached in front of my peers, I led small groups, and I went on mission trips. People sought my advice and looked up to me as a Christian example to follow.

I never thought I'd stare into the night sky with so many questions and hard memories, though now I understand how the "lost sheep" must feel. But I have faith that whether I walk into a valley or turn onto a thorny path, my Shepherd will seek me and care for me.

—*Justin Marr*

I have gone astray like a

Lost Sheep

PSALM 119:176

seek your servant, for I do not forget your commandments.

## PROVERBS 1:7

---

If I see a snake, a mouse, or a spider, chances are I'm going to run the other way screaming. Why? Because they freak me out. It's an unsettling kind of fear.

The fear of the Lord, however, is a good kind of fear ... it's a righteous fear. The best kind. It is my awe of him. What I feel in those times when I'm completely undone with reverence before the One who dwells in unapproachable light, yet who lovingly invites me to encounter him intimately as I worship.

So I fear God by giving him the honor, esteem, and adoration due him. And in doing so, I am ushered into a fresh beginning that opens wide to knowledge, wisdom, and instruction—all of which are worth far more than any understanding this world offers.

The world laughs at godly wisdom and whispers venom to our souls: *Don't have to pay attention to God. Do things your way.*

No thank you, world. I've got a mad crush on my God. The fear of the Lord leads me to depth in a beautifully sacred way. And that's a fear worth running toward full force.

—*Gwen Smith*

PROVERBS 1:7

The fear of the LORD is the beginning of knowledge; fools despise wisdom and instruction.

# PROVERBS 12:5

The truth is, when I encounter a wicked idea, it rarely makes me think of a snake or a skull. Usually the idea sounds really good and makes sense. (Of course I should hurt that person—they hurt me first!) Conversely, righteous thoughts are rarely presented to me by a bird—although that would be *awesome*. Oftentimes, righteous thoughts sound difficult and unappealing. (Forgive the person who hurt me? Are you nuts?)

Making the distinction between the two can be tough. That's why I like that the artist has the two ideas (righteous/wicked) overlapping in the center. Righteous and wicked may be opposite, but for fallen idiots like me, they can blur together. Discerning between the two is difficult to do on my own.

The cool thing about God is that he knows my weaknesses and puts people—or maybe even a bird— in my life to help me in my journey.

*—Jim LePage*

THE THOUGHTS OF THE RIGHTEOUS ARE JUST;
THE COUNSELS OF THE WICKED ARE DECEITFUL.

PROVERBS 12:5

## PROBVERBS 14:12

I've been caught too many times in the labyrinth of my perceived wisdom. I've developed my own how-to plans and DIY fixes for broken relationships, plans for the future, and cleaning up my own mistakes. If there is a problem, my first impulse is always to take care of it myself.

When I rely on myself instead of God, I create a tangled, treacherous maze. My mistakes lead to more mistakes—as well as lies, frustration, and hurt. The path I create only leads to dead ends and destruction.

In this verse, God reminds me that his way is the only way. If I put my trust in him, and him alone, he will make my paths straight (Prov 3:6), and they will not waver. As hard as it is for me to give up control, I know the plans God has for me are better than anything I could imagine (Jer 29:11).

Heavenly Father, I pray that my heart will turn to you instead of my own understanding in times of need.

—*Abby Salinger*

THERE IS A
WAY THAT
SEEMS RIGHT
TO A MAN,

BUT ITS END
IS THE WAY
TO DEATH.
PROVERBS 14:12

## PROVERBS 16:3

_____

For years I was a planner, someone who took great pleasure in making lists and checking off each item, buying gifts far in advance, booking vacation six months in the future. It gave me a sense of accomplishment—and control. But this verse reminds me just how self-centered my behavior can be: *My* plans. *My* goals.

Turns out, like the children's song declares, making those plans was building my house upon the sand. When the rains came down—when my life was suddenly hanging in the balance—my plans were quickly washed away.

Only then did I truly comprehend that God alone knows what will happen in my life tomorrow—or six months from now. At first I panicked, knowing I had no control over the situation. Then, I settled in, remembering I could do nothing more than follow doctors' orders and pray for God's will. My house, barely standing, was built upon the rock after all. Whatever happened, he had me. He has me still.

God has a master plan for the world, and he has a role for each of us in bringing it to pass. As long as we commit ourselves to *his* plan and stand on the foundation of his Word, our future is solid.

—*Rebecca Brant*

Commit your work to the Lord, and your plans will be

# ESTABLISHED

Proverbs 16:3

## PROVERBS 28:13

———————

Like nothing else, sin makes me feel exposed. Like a tree without leaves, I feel like everyone can see right through me. But maybe that's okay. Sometimes I wonder why I'm so averse to the reality of sin. Even the word leaves a bad taste in my mouth—as if writing about it automatically makes me a pushy evangelist, hoping to convince my readers to repent. But sin is a given, right? What human hasn't made a mistake? Who hasn't caused trouble or hurt someone's feelings? It's easy to assume transgression sets me apart from others, but it doesn't. I may feel like I'm alone in a desert, but I'm not. There are too many other people in the same circumstance.

Perhaps that's why confession can be so freeing, because we're all in it together. We often show mercy when others confess because we know what it's like to be in their shoes. Giving and receiving mercy helps us grow. It helps us realize that we don't have to be barren trees in a lifeless desert. Instead, we can be full of life—rooted together in a community of both sin and mercy.

—*Justin Marr*

Whoever
**CONCEALS**
his transgressions
will not prosper,

but he who confesses and
forsakes them will obtain

**MERCY.**

Proverbs 28:13

# ECCLESIASTES 12:1

Nothing beats flying a kite. Kids and adults have enjoyed this pastime for thousands of years, and it's easy to understand why. The total focus required to get the kite airborne, the anticipation of letting out the string, and the elation of seeing your kite shrink into a bright speck against the sky—this pastime has timeless appeal.

When I was a child, my favorite kite was shaped like a red parrot, and on windy days, my dad and I took it to a nearby park. With my gaze fixed on the kite soaring higher, I was filled with pride. Secured on its string, the kite belonged to me, and everyone knew it.

God calls me to love him with childlike enthusiasm and single-minded, whole-hearted worship. He wants me, all of me, without the distraction of bills, arguments, work, or daily routine. That means my total focus and devotion. I shouldn't hide the way I feel about my Lord and Savior—I should display it proudly.

—Abby Salinger

## SONG OF SOLOMON 2:11

My wife and I traveled 3,000 miles from the South—where the sun-soaked summers stretch from May to September—to the Pacific Northwest, the land of perpetual, rainy winter. We live in a misty valley beside a lake, surrounded by tall pine trees that shield us from much of the persistent rainfall. At night, lulled to sleep by the steady, hypnotic patter, we dream of sunnier days.

Winter is a time of longing and anticipation. We yearn for the bleak, grey world to let loose the green and flowering spring. In the Song of Solomon—a sanctified celebration of marital love—winter is the period of engagement, when young lovers long for the spring day they may at last belong wholly to one another.

Then, when the cold and rainy winter months return, the steady fall of rain will match the rhythm of their breathing, and they will drift to sleep in each other's arms, facing each new season in the peace and security of mutual love.

—Tyler Smith

FOR BEHOLD, THE WINTER IS PAST; THE RAIN IS OVER AND GONE.

SONG OF SOLOMON 2:11

## ISAIAH 25:7–8

A black hole is a place where ordinary gravity has become so extreme that it overwhelms all other forces. Nothing escapes—not even light.

Death is a black hole. It is the irresistible force, the immovable object. Nothing and no one escapes death. It swallows everything up.

But Christ's resurrection assures us that a day is coming in which death itself will be swallowed up. A day is coming in which death's grip on its millions of victims will fall slack. They will run free; death will be powerless to stop them, and every tear of mourning will be wiped away.

—*Ray Deck III*

And he will swallow up on this mountain the covering that is cast over all peoples, the veil that is spread over all nations.

# HE WILL SWALLOW UP DEATH FOREVER;

and the Lord GOD will wipe away tears from all faces . . .

**ISAIAH 25:7-8**

## ISAIAH 40:3-4

———————

Imagine riding a camel through the desert, surrounded by swirling sand. Your position is more than a little precarious; the gravity of the situation includes the stress of choosing a direction. Clinging to a scarf as protection from the storm, you can only hope the venture ends safely and at the right destination.

Perhaps you can relate to this scenario, only the desert is your life and the swirling sands are your circumstances. In the middle of this barren wilderness, God and his Word cross your path—perhaps even today as you read in this moment. Suddenly all the zigzags of your journey have led you to this point of recognition: The almighty God of the universe can take any course of our lives and make it pin straight. He can use anything for our good and his glory.

God doesn't merely visit us on the mountaintop, but he holds our hand through every possible terrain. All of creation bows to the one who never leaves our side. With him, the journey is not one to face, but one to embrace.

—*Rachel Wojnarowski*

A voice cries: In the wilderness

prepare the way of the LORD;
make straight in the desert
a highway for our God.

Every valley shall be lifted up,

and every mountain and hill
be made low

Isaiah 40:3-4

## ISAIAH 40:31

I am convinced that yelling to God for help at the top of your lungs is prayer.

Crying out in monosyllables from the pit of desperation—that has been the extent of my prayers at certain times in my life. Neither Sunday school nor Bible college prepared me for the heartbreak that is life. But an incredible movement, what Brueggemann calls "from pit to wing," has begun to characterize my life of prayer.

There is nothing so amazing to me now as being lifted on new wings by God's Spirit after crying out from a place of sorrow. At these times in my life I have felt the breath of God most closely around me and under me, like an eagle must sense a strong current under her wings.

Would I take an easier life in trade for this closeness with God, this soaring, rescuing strength after plummeting to what feels like death? I don't think I would.

—*Carrie Sinclair Wolcott*

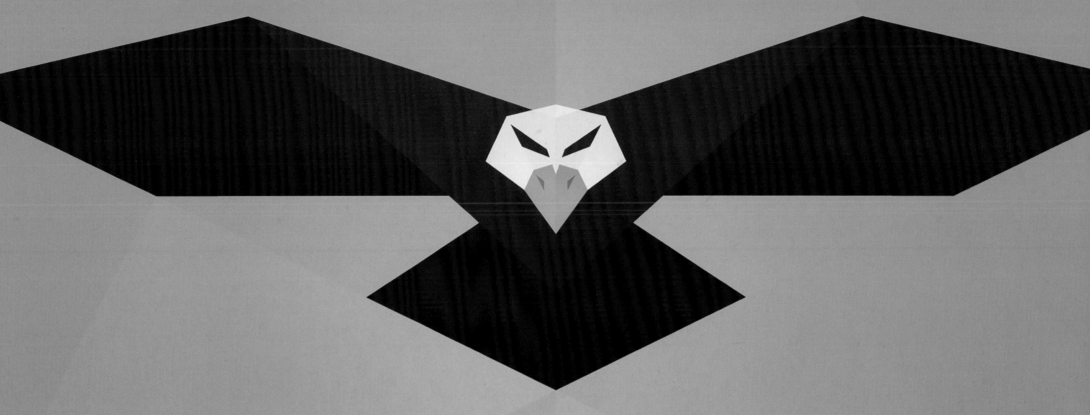

but they who wait for the LORD shall renew their strength;

# they shall mount up with wings like eagles;

they shall run and not be weary; they shall walk and not faint.

**ISAIAH 40:31**

# ISAIAH 53:5

___

When I was a freshman in high school, a good friend of mine got picked on a lot. I vividly remember the day when a particularly aggressive bully was trying to goad him into a fight. I stepped into the space between them and told the bully to leave my friend alone. Fortunately, I was able break up the situation, but it easily could have gone the other way.

More than two decades have passed since that incident. I still see that friend from time to time and often wonder if I'd be willing to do the same for him today.

If he got into a fight, would I stand up for him?

If he had a great debt, would I pay it?

If he committed a crime, would I be willing to take his punishment?

As an adult I have a lot more to lose, so my answer would most likely be no. Fortunately for my friend and for all of us, we don't need to look to a friend to save us. We can look to Jesus. He took the punishment for our sins upon himself, and by his wounds, we are healed.

Look to the cross today. Hope and healing await you there.

—Shaun Tabatt

BUT HE WAS WOUNDED FOR OUR TRANSGRESSIONS; HE WAS CRUSHED FOR OUR INIQUITIES; UPON HIM WAS THE CHASTISEMENT THAT BROUGHT US PEACE, AND **WITH HIS STRIPES WE ARE HEALED.**

ISAIAH 53:5

# ISAIAH 61:1

My first thought is that this sounds like the classic missionary calling, or maybe a description of prophecy: "Bring good news," "the Spirit of the Lord," "sent," and "proclaim liberty" all sound grand, supernaturally inspired, foreign to "normal" life.

But then I realize: It's describing the mosaic of life in which we live. The poor? I see them on my walk to work or the grocery store. The brokenhearted, the captives, those who are bound. They're friends, family, coworkers. It's the friend alienated from her family, the coworker who's stressed and in need of a helping hand. And when we reach out, the Spirit of the Lord is with us; the good news is coming to fruition all around us, all the time.

The good news is a grand calling, yes. But as Jesus showed, sometimes that supernatural calling looks like playing with little children, or using the resources you have to feed your neighbor—or 5,000 neighbors—who missed lunch. Healing, liberty, the fulfillment of prophecy? Of course it's supernatural—and it crashes into our every day.

—*Abigail Stocker*

THE SPIRIT OF THE LORD GOD IS UPON ME BECAUSE
THE LORD HAS ANOINTED ME TO BRING
GOOD NEWS TO THE POOR;

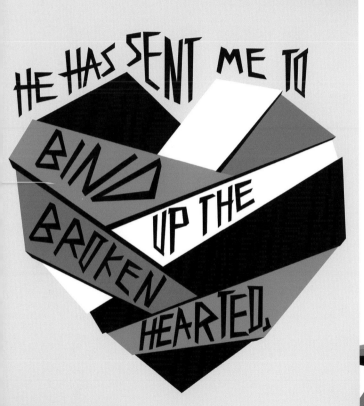

HE HAS SENT ME TO BIND UP THE BROKEN HEARTED,

TO PROCLAIM LIBERTY TO THE CAPTIVES,

AND THE OPENING OF THE PRISON TO THOSE WHO ARE BOUND...

ISAIAH 61:1

## EZEKIEL 37:3

Dry bones don't walk. Even a child knows that. And yet, *Can these bones live?* God asks. *Can these bones live?*

Left on their own, these bones would remain dry and dead. To ask if they can live is as absurd as asking your toddler to do you a favor and change the oil in the car while she's up.

I was at a candlelight church service recently when I was taken off guard by warm tears streaming down my cheeks. The room was dark, as it had been for some time. But suddenly, there was light—just a few flickers in a corner at first, then enough to see again.

This particular season of life had felt like that dark room. Without even realizing it, I had grown so accustomed to the dark that I was sure it would remain. I had lost hope that it would ever be light again. And then, all of a sudden, through tear-filled eyes, I could see.

*Can these bones live?* God whispers in the dark. O Lord God, you know.

—*Ryan J. Pemberton*

AND HE SAID TO ME, SON OF MAN, CAN THESE BONES LIVE? AND I ANSWERED, O Lord GOD, You Know

EZEKIEL 37:3

## DANIEL 11:35

I don't like pain. I like to be comfortable. In fact, for a long time, my goal was for life to be as comfortable and easy as possible. Don't risk, you might screw up. Accumulate stuff that makes you feel happy. Don't love, you might get hurt. The thing is, when I avoid the valleys, I miss out on the peaks. That makes for a pretty lame existence.

So I started taking risks, and it changed me. It was as if the things that had blocked my heart and soul for so long were being chiseled off, revealing the truest version of me. Exposed to pain and hurt, but—even more—exposed to new levels of joy and life.

If there was ever someone who lived a life of radical risk and danger, it's Jesus. Speaking out against the religious elite? Risky. Loving your enemies? That could get you killed. And it did—but Jesus was alive in a way that I want to be.

Forget comfort. Give me Christ-like danger.

—*Jim LePage*

. . . and some of the wise shall stumble,

# SO THAT THEY MAY BE REFINED, PURIFIED, AND MADE WHITE,

until the time of the end, for it still awaits the appointed time.

DANIEL 11:35

## JOEL 2:28

God promises fantastic and supernatural gifts to his beloved creation: resurrection, renewal, and everlasting peace. Here is another of God's extraordinary promises, mysterious in its supernatural and fantastical aspects.

I hardly have enough power of imagination to envision what I would look like resurrected or freed from the burden of sin. Throughout the Bible, God works through miracles—things beyond our ordinary sensibilities and outside the realm of *seeing is believing*.

Perhaps this is why God speaks through prophecy—to tell us what we can expect next. Perhaps this is why God promises dreams and visions—to provide a bridge between the limits of my mind and the wonders of his.

—*Brandon Rappuhn*

And it shall come to pass afterward, that

# I WILL POUR OUT MY SPIRIT ON ALL FLESH;

your sons and your daughters shall prophesy, your old men
shall dream dreams, and your young men shall see visions.

JOEL 2:28

# MICAH 6:8

I struggle with feeling that I have to do something in order to be accepted by God. It doesn't seem like it could possibly be enough just to *experience* salvation by grace through faith. Could it really be that simple? In a word, yes. Faith is all that God requires of us.

Why then does the Prophet Micah give us a list of requirements to be considered acceptable in God's sight? In the preceding verses, the Prophet Micah asks, "With what shall I come before the Lord?" As potential answers, he lists many types of sacrifices described in Old Testament law before reaching his conclusion this verse: Sacrifice is not what the Lord wants from his people—not on its own, anyway.

The to-do list in Micah 6:8 isn't actually a to-do list at all. Doing justice, loving mercy, and walking humbly are evidence of a changed heart—the willingness to follow the spirit of the law rather than the letter of the law.

—Jessi Strong

He has told you, O man, what is good;
and what does the Lord require of you but to
love KINDNESS,
DO JUSTICE, and to
and to WALK humbly WITH YOUR GOD?

MICAH 6:8

## ZECHARIAH 2:10

I'm a staunch introvert. Solitude is a rare and precious gift, and at social gatherings I try my best to blend into the wallpaper. Given the choice, I will stay home with a good book over having any human interaction.

As you can imagine, dancing is the farthest thing imaginable from my nature. The only singing I've ever done has been in the back of a church choir. Yet in this verse, God is calling his children to lose themselves in praise. What could cause a borderline recluse like me to celebrate with wild abandon?

God uses verses like this to remind me that he wants to push my comfort level. His relationship is not one I can deal with at a distance—it's up close and personal. So personal, his only Son became mortal to die for my sins so that I can have a direct relationship with the Heavenly Father.

If that's not a reason to dance in the streets and sing at the top of my lungs, what is?

*—Abby Salinger*

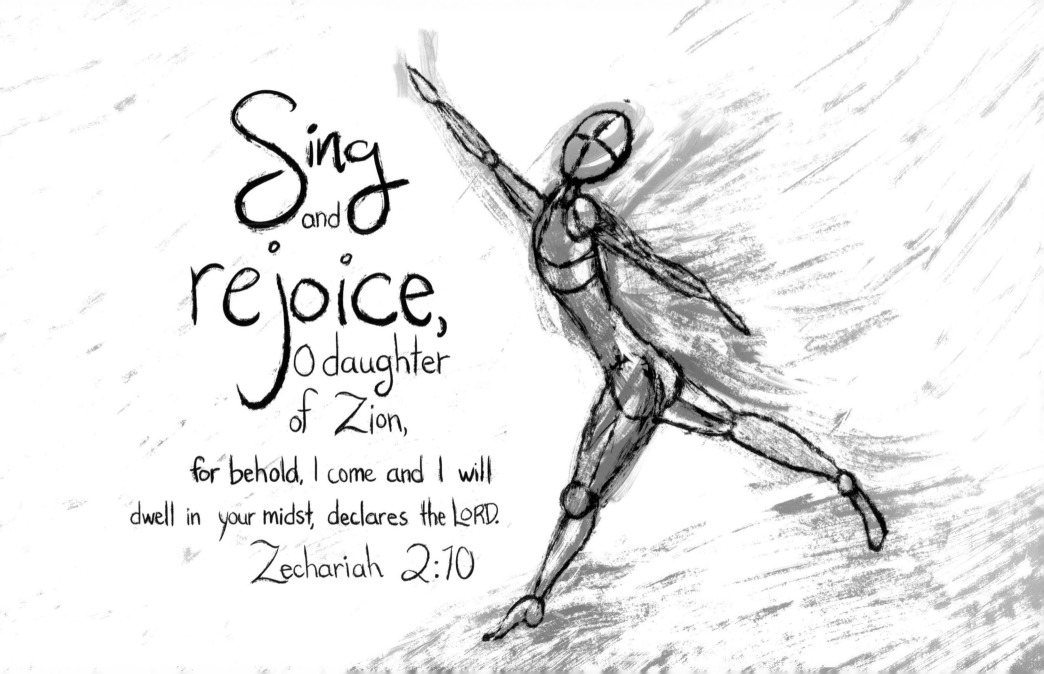

Sing and rejoice, O daughter of Zion, for behold, I come and I will dwell in your midst, declares the LORD.

Zechariah 2:10

## MALACHI 3:6

I wonder what would happen if God changed his mind as frequently as I do.

I change my mind as quickly as new situations develop. If I had a dollar for every time I change my opinion about specific politicians, I could retire and fund the government myself. Even in trivial matters, like where we'll put the Christmas tree each year, I change my interests. I go through seasons of liking some radio stations to suddenly hating them.

Imagine if God frequently changed his mind. Moses, David, Solomon—these men ruled Israel for the majority of their lives, and God didn't change his mind about them when they fell into sin. And God doesn't rearrange the furniture on a whim. Imagine tomorrow the Nile River sitting in my backyard, or our solar system suddenly containing three suns!

God's constancy is a source of comfort in this world that changes so frequently. His promises have never changed, and his love is always waiting for me when I turn to him.

—*Brandon Rappuhn*

# For I the LORD do not change;

therefore you, O children of Jacob, are not consumed.

MALACHI 3:6

## MATTHEW 28:18

———

Jesus' statement in this verse is not particularly astounding. After all, he created the entire universe. Everything that exists came about through him. He is the one who continues to sustain the world. And let's not forget that Jesus is God—the Word incarnate. So it's really no surprise that Jesus should have such authority.

The surprise is what he does with it.

Most human rulers use their authority to gain more power. They build up a kingdom to serve themselves. But Jesus is like no other king, and his kingdom is not of this world. Jesus chose to strip himself of power. The Creator entered creation as a human. The King stooped down to wash the feet of his subjects. The Master spent his life as a servant. And then, in the ultimate sacrifice, the Giver of life gave his own life in order to save us.

—*Chuck McKnight*

And Jesus came and said to them,

# ALL AUTHORITY IN HEAVEN AND ON EARTH HAS BEEN GIVEN TO ME.

Matthew
28:18

## MATTHEW 14:30–31

---

For a moment—a few steps—Peter saw what was possible with pure, unadulterated faith. Can you imagine what that moment might look like in your life? To have the audacity to trust God so fully that you could do the impossible? Peter heard "Come," so he got out of the boat—before he saw the wind and the waves, before reality sank in.

With Christ, it doesn't matter what reality we're facing. It doesn't matter that we weren't made to walk on water. The One who made us says, "Come." He doesn't wait for the winds and waves to die down—he commands them.

Too often in my life, I let reality sink in, and I never leave the boat. I'm stranded by my lack of faith. But you know the best part? When Peter doubts, Jesus doesn't let him sink. He reaches out and rescues him. So when Jesus says, "Come," what are we waiting for?

—Ryan Nelson

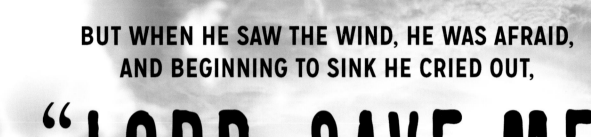

BUT WHEN HE SAW THE WIND, HE WAS AFRAID,
AND BEGINNING TO SINK HE CRIED OUT,

## "LORD, SAVE ME."

JESUS IMMEDIATLELY REACHED OUT HIS HAND AND TOOK HOLD OF HIM,
SAYING TO HIM, "O YOU OF LITTLE FAITH, WHY DID YOU DOUBT?"

## MARK 9:35

Let's be honest. Jesus' instructions to his followers don't always make much sense. The kingdom of God that he preached seems counterintuitive. It contradicts our normal way of thinking. Could it really be true that we find our life by losing it? How could it be better to give than to receive? Can we actually be expected to love our enemies? And how is it that the first becomes the last and the last becomes the first? No wonder so many count our gospel as foolishness.

But let's not forget that this is how God operates. Jesus—who has every right to be first—made himself last. He gave up his power and prestige to become a servant. And he achieved his greatest victory through apparent defeat. Jesus gave up his life, and in so doing, he made eternal life available to all.

If this is how Jesus lived and died, then surely we ought to follow in his footsteps. For his sake, we can abandon the pursuit of first place.

—*Chuck McKnight*

And he sat down and called the twelve. And he said to them,

# IF ANYONE WOULD BE FIRST,

he must be last of all and servant of all.

MARK 9:35

## LUKE 1:49

I have never birthed a miracle. I am not like Mary, who delivered a king from a womb marked by a scarlet letter, who sang a magnificent song of praise to a God who did mighty things—and put her in impossible circumstances. It is enough that I go through the motions of my day, one foot in front of another, trusting he won't mark me as anything other than a good and faithful servant.

The truth is, I am afraid of doing mighty things. I am afraid he will pick me to push back darkness and deliver hope. I am afraid he will make me sing of his might with all of mine.

Try as I may, I cannot match his might. I find comfort in this truth today: that he who is mighty has done great things. No miracle will come from *this* person except through him. Jesus said, "My food is that I do the will of the one who sent me" (John 4:34), and I subsist on this today: All my action, all my work, and all my service is born of the One who is mightier than I can imagine.

He births miracles, not me.

—*Lore Ferguson*

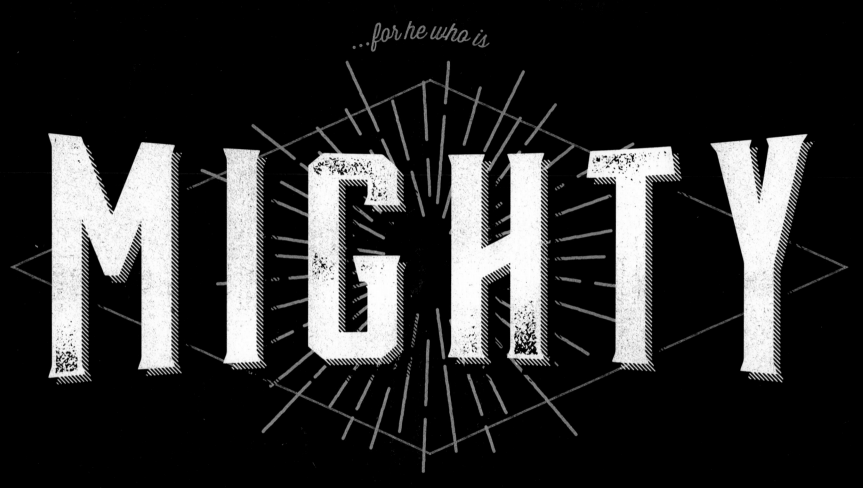

...for he who is

# MIGHTY

has done great things for me, and holy is his name.

LUKE 1:49

# LUKE 15:7

—————

As a child raised in a Christian family, I always had a hard time identifying with Jesus' parables describing the lost being found. The coin, the sheep, and the prodigal son were all metaphors for sinners who went from rebellion against God to reconciliation with him. I felt more like an unsought coin, one of the 99 sheep, or the elder brother. Was there room in those stories for someone who has known him all her life?

I was never more relieved than when my teenage self first understood I was not as good as I thought I was. As humans we're all sinners in rebellion against God, and when he calls to us, we each become the one found sheep. Nothing brings me to my knees in gratefulness like the realization that the glorious God of the universe went looking for me when I was lost. His glory is revealed when he rescues irredeemable people.

—*Jessi Strong*

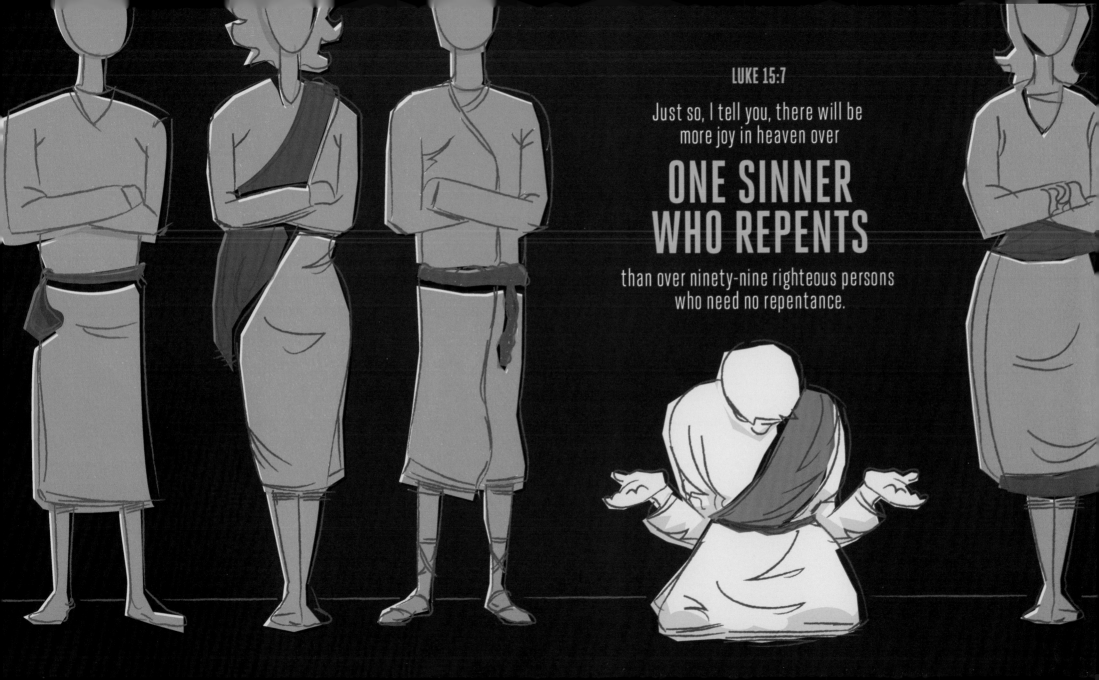

LUKE 15:7

Just so, I tell you, there will be
more joy in heaven over

# ONE SINNER
# WHO REPENTS

than over ninety-nine righteous persons
who need no repentance.

## LUKE 20:25

"Jesus isn't interested in your money," the pastor said, and all the ears in the room perked up. "He wants your heart."

It reminded me of the time a group of spies approached Jesus and asked, "Is it okay for us to give money to Caesar, or not?" They hoped Jesus would say, "Nope, I want all of it," and then the state could snatch him up and that'd be it. But that's not what he did. "Whose picture and name does your money have on it?" Jesus asked.

The pastor said, "What he wants is much more valuable." Which is another way of saying, "Render to Caesar the things that are Caesar's and to God the things that are God's."

Does Jesus care what I do with my money? Of course. But what he—and this pastor—were saying is that my obedience must be reserved for God. And my heart steers all of it: my money, my time, even the words on my lips. What Jesus desires, ultimately is that I let go of anything that prevents my following him.

—Ryan J. Pemberton

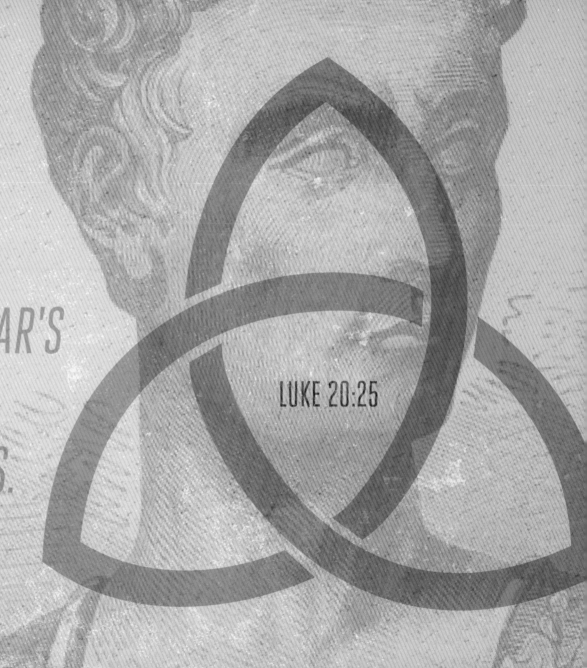

he said to them,

then render to Caesar

THE THINGS THAT ARE CAESAR'S

and to God

THE THINGS THAT ARE GOD'S.

LUKE 20:25

## JOHN 1:16

———

Grace is the reason I am saved. Grace is the reason I can be sure that my salvation will take me to be with my Lord in heaven when the day comes. And all I had to do was ask for it.

I'm not perfect—in fact, I actually have quite a lot of flaws—but my Lord doesn't care. He loves me for every bit of who I am. My short stature, my awkward demeanor, my occasionally poor attitude ... my God looks past all of those things and sees only the beautiful creation he formed me to be.

Because of his immense love for me, I have been washed by his ever-present grace to be forever accepted into his great and mighty kingdom. And you know what makes this even better? You can be washed by grace, too. All you have to do is ask.

—*Lauren Visser*

AND FROM HIS FULLNESS WE HAVE ALL RECEIVED, GRACE UPON GRACE

JOHN 1:16

# JOHN 3:3

What in the world does it mean to be born again? How does that even happen?

Not only were these my thoughts the first time I read this passage, but they were also the thoughts of those who heard it from Jesus himself. The idea basically didn't make any sense.

What I realized is that Jesus is referring to a change of heart. As I came to understand that he paid the price for my personal sins on the cross and rose again from the grave, I put my trust in him and chose to follow him from that day forward.

At that point Jesus changed my heart, and I was born again. You too can see the kingdom of God by following Jesus. How's your heart?

—Mike Mobley

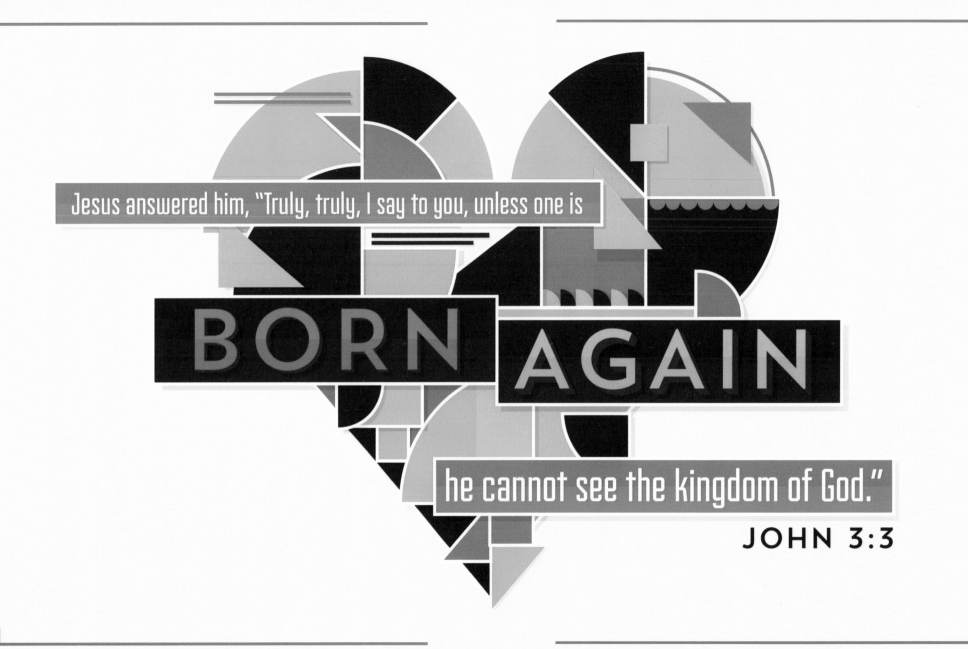

Jesus answered him, "Truly, truly, I say to you, unless one is BORN AGAIN he cannot see the kingdom of God."

JOHN 3:3

## JOHN 3:16

———

John 3:16, perhaps the most well-known verse in the Bible, has been repeated in Sunday school, preached from pulpits, and murmured by new believers. It is the most simple, beautiful summary of God's relationship with all of humanity, for all of eternity, and it's the foundation for everything we believe.

It shows God's love, which is so true he would sacrifice his only Son for sinners like us. It shows his grace, which is so benevolent he would forgive us simply for believing in his sacrifice. And it shows his mercy, which is so strong he would offer us the wonder of spending eternity with him, despite our iniquities.

God loves you, and he loves me. Our salvation lies in his open hand. Will you take it?

—*Sherri Huleatt*

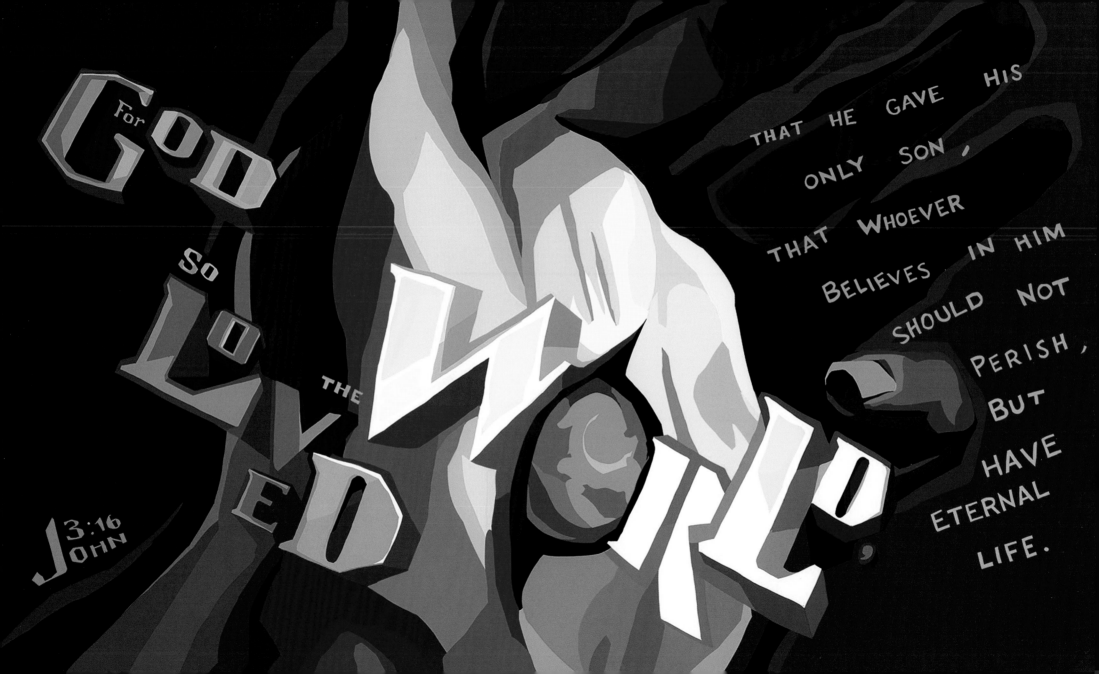

## JOHN 5:24

---

For a long time, I thought the most powerful thing about this passage was that Jesus helps me avoid death. Jesus tells me, "Put your faith in me and no more death for you." That's a pretty good deal, right? Thankfully, God doesn't settle for pretty good.

Not only does Jesus stop my one-way trip to death, he gives me a new destination—life. In fact, this new destination is actually Jesus himself. The ugliness I was saved from pales in comparison to the beauty of what I've been saved to. I was saved from my selfishness and pride, but I was saved to humility and sacrifice. I was saved from a life of judging others, but I was saved to a life of loving others.

I was saved from death, but I was saved to life.

—*Jim LePage*

Truly, truly, I say to you, whoever hears my word and believes him who sent me has eternal life.

**HE DOES NOT COME INTO JUDGMENT, BUT HAS PASSED FROM DEATH TO LIFE.**

John 5:24

# JOHN 8:32

———

In the light, everything is exposed: my gifts and strengths, but also my brokenness, my flaws, and my inconsistencies. This truth is pure gift where I am loved as I am, unpolished and shadowed in places.

I cannot look down on anyone from here. The truth that sets me free is neither factual nor moral. This freeing truth is the gut-wrenching admission that, at every moment, God's Spirit holds me up. In this truth, I stand with the rest of humanity: open-handed, in desperate need of the miracle of God's life.

The minute I forget my own need for God's daily forgiveness and grace, I sink like a cold stone. I get busy preening, trying to look good, hiding my faults. But in my true place of need, I float in the light of God with a free enough spirit to love as Jesus loved. And I am always stunned by his extremely radical love: the kind that rolls stones from graves.

—*Carrie Sinclair Wolcott*

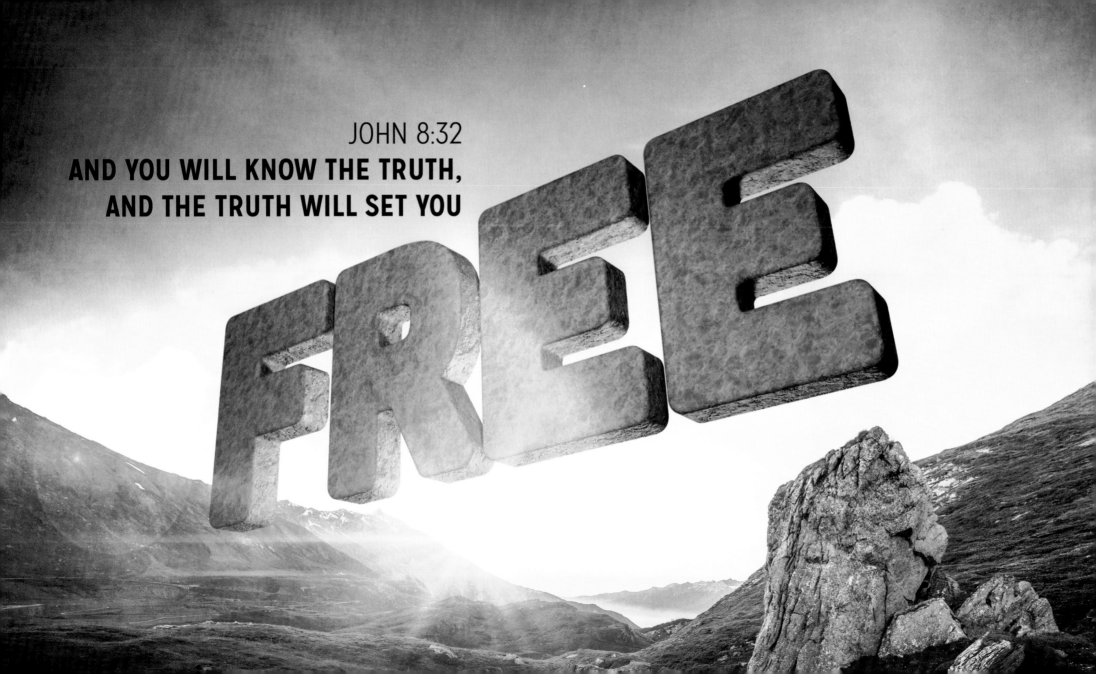

JOHN 8:32

**AND YOU WILL KNOW THE TRUTH,
AND THE TRUTH WILL SET YOU**

**FREE**

## JOHN 14:6

———

Some people get twitchy reading this verse. Its exclusivity is unnerving. I've never really had an issue, though. Then again, I've had a lot of experience trying the alternatives.

As a teen, I read up on Eastern spirituality, desiring "inner peace" (or so I'd say to impress girls, which it didn't). I dipped a toe in Baha'i waters because of a girl I liked, but their practices were more humorous than helpful. For the most part, I tried to be a good person, which was also a problem, since I was kind of a jerk.

No matter what I tried, I was in trouble. Every road I went down was found wanting. None had an answer to the problem I faced: the deadness of my heart. And truthfully, I didn't even realize this was my problem.

But Jesus did. Jesus in effect tells us, "What you're looking for is me." There is no rest in anyone or anything but him. There is no path that can take us where we need to go that doesn't start and end with him. He is the way, the truth, and the life. There is no alternative, and for that we should rejoice!

—Aaron Armstrong

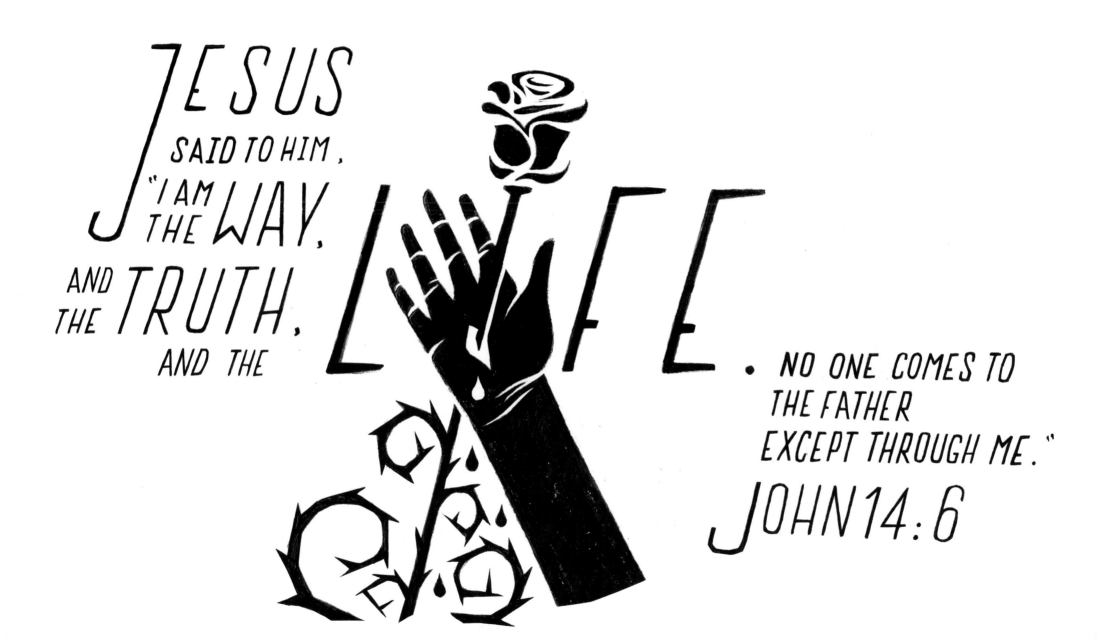

JESUS SAID TO HIM, "I AM THE WAY, AND THE TRUTH, AND THE LIFE. NO ONE COMES TO THE FATHER EXCEPT THROUGH ME." JOHN 14:6

## JOHN 14:27

―――――

It's a good thing God doesn't give as the world gives. The world is a scary place—and I don't just mean because of the violent stories we hear in the news. I'm talking about the pressure and anxiety of day-to-day life, trying to fit in, making enough money, and driving in traffic surrounded by impatient people. Lies, sin, attitudes that dishonor God and people—I wouldn't stand in line to receive anything the world is handing out.

But Jesus offers peace, a concept I usually imagine as lush meadows and babbling brooks in pastel shades of green and blue. This artwork is not even close to that, and that's what I like about it. It doesn't represent peace in the traditional, passive sense. Instead, it reminds me that the peace Jesus offers cost him dearly. He paid with his blood and his life. His peace is radical. It's countercultural. And in this harsh world, that's just the kind of peace we need.

—*Lynnea Fraser*

# PEACE

I LEAVE WITH YOU; MY PEACE I GIVE TO YOU.

NOT AS THE WORLD GIVES DO I GIVE TO YOU.

LET NOT YOUR HEARTS BE TROUBLED, NEITHER LET THEM BE AFRAID.

JOHN 14:27

# JOHN 17:4

———

Reflecting on this all-encompassing, gospel-rich text, I was struck by Christ's heaven-to-earth accomplished work.

Humble he came to man as man, hanging out with stinky fishermen and dirty farmers. He fished and farmed like anyone else while on this heaven-sent-to-earth mission. He knew water's danger, the sure footing of land, and the soil's richness. The woodwork he crafted, he did knowing timber would undo him.

He taught fishermen to catch more than they could imagine—men unleashed for the great catch of souls. He told those farmers he would become broken bread for them to feed on, the grain of seed to die so the new seed might spring forth and a white harvest reaped.

In glorifying the Father, Christ reflects him to us. He exhibits humility and power: humility to do the stinky and dirty work and power that calms storms, nets massive catches of fish, and multiplies bread and fish.

Am I learning to do earth-to-heaven work like Jesus' heaven-to-earth work? Am I learning to glorify the Father and accomplish something eternal?

*—Joey Cochran*

I GLORIFIED YOU ON EARTH, HAVING ACCOMPLISHED THE WORK THAT YOU GAVE ME TO DO.

JOHN 17:4

# JOHN 17:17

Truth is relative, right?

Today this is exactly what the world teaches. Something may be good for you but bad for me. Or it's okay to do things that we know are bad as long as it's for a good cause.

Well, according to these words—spoken in Jesus' prayer to God the Father—truth is not relative. In fact, the only truth that we can count on to sanctify us from the world as believers is the truth found in God's Word, the Bible.

Consider what it must have been like to be one of those disciples who walked with Jesus when he was on earth. He continually taught them from his Word—the truth. And in his final hours, as he faced certain death, what was Jesus doing? Thinking and praying for them and for us!

How wonderful is it to know that Jesus prayed for his disciples and even for us, that the truth of his Word might protect us from the world. That Word is our measuring stick for the choices we make to do good or not.

The truth never changes based on circumstances. I am so thankful that we can count on that.

—*Pamela Rose Williams*

SANCTIFY THEM IN THE TRUTH;
YOUR WORD IS TRUTH

JOHN 17:17

## JOHN 21:12

———

There's something deeply intimate about sharing a meal together, but coming together around a table to eat is so common that we often overlook its significance.

In his final hours, Jesus chose to share a meal with his closest friends. He established a new covenant with humanity at that table. After his death and resurrection, he appeared to those same friends and asked them to share a meal with him again.

The situation borders on bizarre. Jesus' disciples, believing him to be dead, are confronted by the apparition of their fallen teacher. Instead of running, screaming, or disbelieving, they immediately know who he is. They have sat with the Lord and shared a meal.

When Jesus bids us, "Come," we know it is he who is calling because we too have shared a meal with him—the bread of life.

—Jake Mailhot

Jesus said to them, "Come and have breakfast."

Now none of the disciples dared ask him, "Who are you?"

# THEY KNEW IT WAS THE LORD.

John 21:12

# ACTS 1:8

This verse is a promise and command all in one. We will receive power, and we will be witnesses. It doesn't say we have to go be witnesses on our own, or in our own strength. And I don't know about you, but I find great relief in that; my own strength is pretty small. I'm one of the tiny flames on the edges, whose light wouldn't make it very far—for sure not to the ends of the earth. The promise of help brings me reassurance.

But Jesus also says, "You will by my witnesses." He doesn't say "you can" or "if you feel like it, you have the option." By the power of the Holy Spirit we are called to be the big flame—no excuses. We are Christ's image-bearers, and it's time to stop hiding his light. Like the old song says, "This little light of mine, I'm going to let it shine."

—Lynnea Fraser

BUT YOU WILL RECEIVE POWER WHEN THE HOLY
----> SPIRIT HAS COME UPON YOU, AND <-----

YOU WILL BE MY WITNESSES

IN JERUSALEM AND IN ALL JUDEA AND SAMARIA,
<------- AND TO THE END OF THE EARTH. ------->

ACTS 1:8

## ROMANS 8:15

———

Sins—past and present—can feel like chains. They remind me of the person I thought I left behind—the old me, who acted in supposed freedom yet was caught in a sinister type of slavery.

But Paul tells me another story about my identity. When Christ died and then rose, he turned my narrative from one of fear and slavery to one that's full of hope. I'm not bound to my sin or my past. My story is shaped by a tale of adoption and the love of a good Father.

That changes everything. I'm not bound by fear; I'm fueled by love. God is not a far-off figure who disapproves of me when I mess up; he's a God who has drawn near to me and grafted me into his family. Now I can move forward, confident in the freedom that Christ has bought for me.

—Rebecca Van Noord

FOR YOU DID NOT RECEIVE THE SPIRIT
OF SLAVERY TO FALL BACK INTO FEAR,

## BUT YOU HAVE RECEIVED THE SPIRIT OF ADOPTION AS SONS,

BY WHOM WE CRY, "ABBA! FATHER!"

ROMANS 8:15

## ROMANS 8:37

———

In today's society, confidence is something we struggle to maintain. There are so many young adults who battle with eating disorders or self-mutilation because they just don't see how valuable and loved they are. It tears my heart to shreds knowing how many young men and women—even children—believe they have no worth or purpose in this life.

Even through all of these horrible, earthly trials, though, the Apostle Paul assures us that we are more than conquerors, which is only made possible because of Christ's love for us.

I keep this verse near to my heart because of the hope it brings me and our culture. Despite the stretched truths the media feeds us, we can share the good news: Jesus loves us, and we are more than conquerors.

—*Lauren Visser*

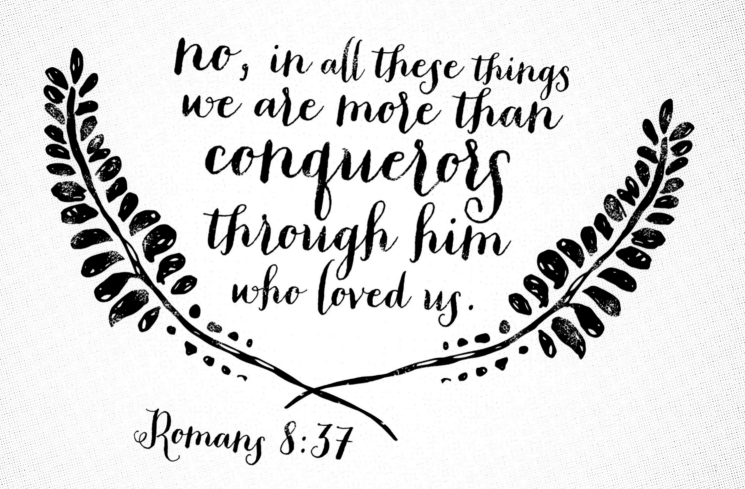

no, in all these things we are more than conquerors through him who loved us.

Romans 8:37

# 1 CORINTHIANS 9:22

Everyone deserves to hear the gospel in a way they can understand. To me, becoming all things to all people means having the humility and the empathy to recognize how different people experience the world. It's listening and understanding well enough to communicate God's love. We are all made in God's image—not just me, and not just you—and our perspectives about him emerge from a lifetime of experience.

Everything in my life must point to Christ. Not just part of my life, and not just part of the time. The more a part of my life is public, the more conscious I must be about others' perspectives. Justifying a decision to myself isn't all that matters. While something I do or enjoy might be fine for me, someone else might not agree. If I love my neighbor and desire to lead as many people to Christ as possible, I will need to leave some things on the altar.

—*Ryan Nelson*

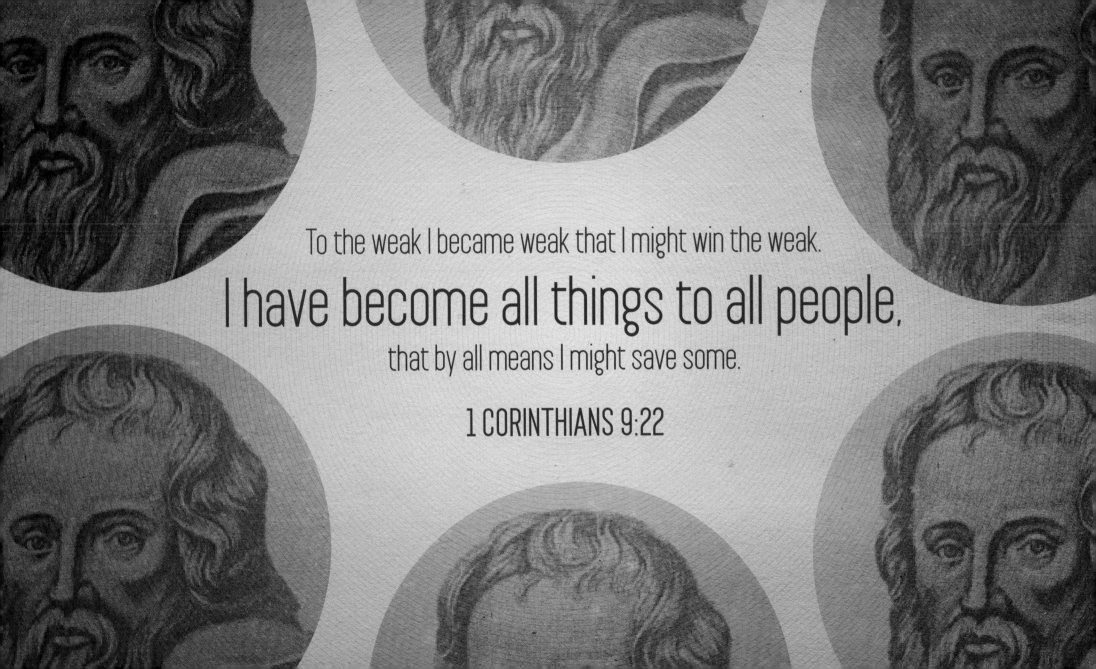

To the weak I became weak that I might win the weak. I have become all things to all people, that by all means I might save some.

1 CORINTHIANS 9:22

# 1 CORINTHIANS 10:31

I love making checklists. There are few things I find more joy in than completing something on my list and checking off the box. Each of us spends our days a little differently: We go to work, we care for our loved ones, we attend class, we pursue hobbies. But I tend to give precedence to the things that need to be done right away, which quickly fill my schedule.

I think, "If I can just get these things done, then I'll have time for things that are more important."

It's easy to think that God doesn't care about the mundane, the routine, and the undesirable. But that's the beauty of it: He does. In the words that you speak, in the way you treat others, and even in the day-to-day responsibilities, do everything for the One who gave you the means to do them.

He gives us the ability to accomplish everything we do, and we can thank him by offering even the least of our tasks to him as worship.

—Pam Bauthues

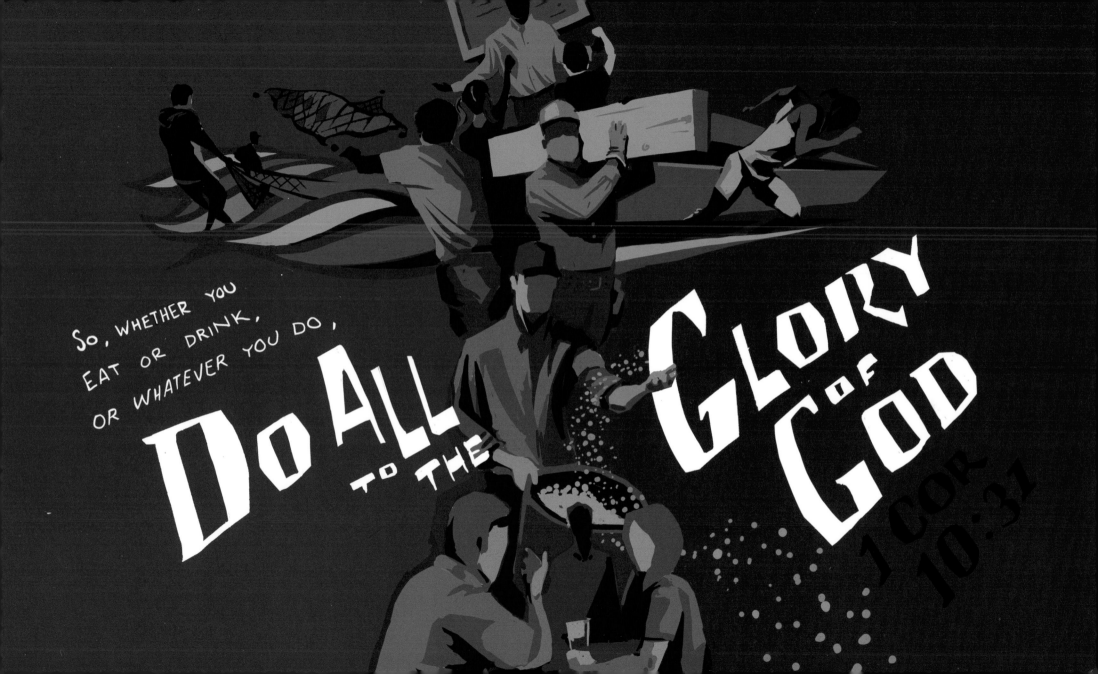

# 1 CORINTHIANS 13:13

―――――――

"But the greatest of these is LOVE."

Let that sink in: Love is more important than faith? Love is more important than hope? What an amazing reminder! It is only through love that faith and hope are even possible. God's love encompasses faith and hope and then some.

So often I feel myself going through the motions. I go to church and sing the songs. I walk the streets but don't help anyone who is hurting around me. There is no love in the way I interact with strangers, no love behind my worship. It begins to feel so empty, and I become selfish, cold, and arrogant. I crave love and feel starved of it.

Without love I do not see others how Jesus sees them—as beautiful creations, worthy of redemption. I begin to see people as worthless, and the only way to put these thoughts to rest is with Christ's all-consuming love.

—*Katie Monsma*

So now faith, hope, and love abide, these three;

BUT THE GREATEST OF THESE IS LOVE.

1 CORINTHIANS 13:13

# 1 CORINTHIANS 15:19–20

―――――――

"He has risen indeed," I respond with the congregation. Christ has been raised from the dead, and the tomb is empty. I've heard these things in Sunday school since before I can remember. A drawing of the rolled-away stone, like this one, was in every picture-Bible I owned and described in every Easter message I heard. I can sometimes take this image—and the event it illustrates—for granted. If I'm not careful, I forget how crazy, world-shattering, and counterintuitive it is.

But this image makes all the difference. It's one I need to dwell on, taking the time to pull out bright crayons and color in the lines. I need to revel in the knowledge that we as Christians serve a God who lives, who conquered death, who offers hope in this life and the next. It doesn't get any better than that.

—*Lynnea Fraser*

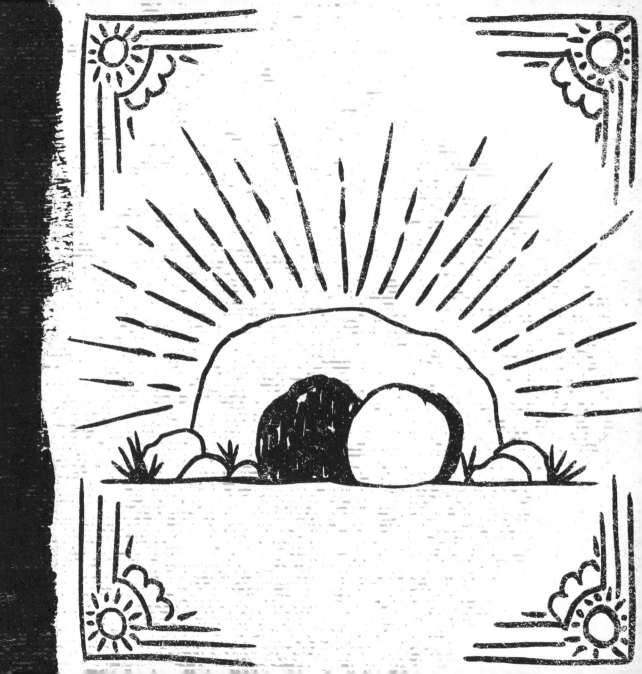

IF IN CHRIST WE HAVE HOPE IN THIS LIFE ONLY, WE ARE OF ALL PEOPLE MOST TO BE PITIED. BUT IN FACT **CHRIST HAS BEEN RAISED FROM THE DEAD,** THE FIRSTFRUITS OF THOSE WHO HAVE FALLEN ASLEEP.

1 CORINTHIANS 15:19–20

## 2 CORINTHIANS 3:18

She's the college freshman, insecure in her ideas and her place in the world, feeling awkward, longing for a higher sense of calling than the humdrum of classes and to-do lists.

She's the girl who loves Narnia, who doesn't really regard her assigned reading from C. S. Lewis as homework, who's exhilarated to encounter a like-minded spirit in his written words, pondering beauty and longing to be united with it.

For even as we are like birds gliding, unable to articulate the beauty they already are, so we are moving from the glory of our everyday now to becoming more like Christ as we train our vision upon him. We are already created in our Creator's image, and, save the sacraments, the beauty and glory of Christ is most nearly manifest in our neighbors, every day.

She's the person I'm amused to remember—and the foundation for who I am now. I fancy I'm wiser, years later—but now, as then, I cling to belief that I'm being transformed, one degree of glory at a time.

—*Abigail Stocker*

AND WE ALL, WITH UNVEILED FACE,
BEHOLDING THE GLORY OF THE LORD, ARE BEING

transformed

INTO THE SAME IMAGE FROM
ONE DEGREE OF GLORY TO ANOTHER....

2 CORINTHIANS 3:18

# 2 CORINTHIANS 5:8

---

The key to working with fiber—whether yarn, floss, or fabric—is to keep the proper tension.

I've loved handcrafts ever since I was a child, and I've made many samplers for friends and family. Birthdays, anniversaries, other good tidings—and many have referred to home. *Home is where the heart is. Jesus is the heart of home.* My favorite is one that hangs in my own entryway: *Home is where you hang your hat.*

It reminds me that as believers, we must find the right tension between engaging in this life and longing for the one to come. We too easily focus on the here and now, but life can change in a blink. Best not to get comfortable with putting our trust in wealth, status, and possessions; better to be ever-ready to pick up and follow our Lord whenever he calls, and set our heart on our true home with him.

I love life, and there are so many things I still want to see and do, but I hold on loosely. I would rather be at home with the Lord. I'm ready to move on, to take my hat off the peg and exchange it for a crown to lay at his feet.

*—Rebecca Brant*

YES, WE ARE OF GOOD COURAGE, AND WE WOULD
RATHER BE AWAY FROM THE BODY AND AT

WITH THE

2 CORINTHIANS 5:8

# 2 CORINTHIANS 7:10

—————

We all have felt shame over wrong behavior. Paul acknowledges that remorse for sin is a universally understood feeling—not exclusive to Christians. But I can't ever recall a time in my life when just feeling bad about the things I'd done changed my behavior in any way. It's not enough to merely feel sorry for our sins.

In 2 Corinthians 7, Paul distinguishes between worldly grief and godly grief. Worldly grief produces only emotion. Godly grief—rooted in the knowledge that Jesus Christ bore the punishment of our sins by his death on the cross—produces true repentance. And repentance leads to salvation, a renewed heart, and a changed life.

—Jessi Strong

For godly grief produces a

# REPEN✝ANCE

that leads to salvation without regret,

whereas worldly grief produces

# DE☠TH.

## GALATIANS 3:11

I've always been a rule-follower. As a kid, I followed my adventurous older sister around, tearfully begging her not to get us in trouble again. I dreaded the inevitable moment when we would get caught, whether it was sneaking candy from the pantry or playing with matches unsupervised.

As an adult, I often wish I could choose the law over faith. It seems easier—all the rules are laid out, and I have only to follow them. I don't have to examine my heart or my motives. But it isn't enough to blindly follow rules without actively seeking to trust and follow God. Just as I broke my parents' rules so often as a child, it's foolish of me to hope to justify myself to God by my performance.

Paul reminds the Galatians that the law was never the ideal system for salvation. "No one," he says, "is justified before God by the law." Following the rules can't save me—God is concerned with the state of my heart.

—Jessi Strong

Now it is evident that no one is justified before God by the law, for
THE RIGHTEOUS SHALL LIVE BY FAITH.
Galatians 3:11

# GALATIANS 5:22–23

The first time I read this verse, I thought of these nine qualities as separate fruits of the Spirit. Love, joy, peace, patience, kindness, goodness, faithfulness, gentleness, and self-control were nestled in a bowl together like something from a still-life painting.

But the word "fruit" is singular here. They're all one fruit. If the Holy Spirit is at work in me (and he is), then I am going to start bearing this nine-sided produce. Because that's who I am now.

—*Jeffrey Kranz*

BUT THE FRUIT
OF THE SPIRIT IS

LOVE JOY PEACE
PATIENCE KINDNESS
GOODNESS FAITHFULLNESS
GENTLENESS
SELF-CONTROL;
AGAINST SUCH THINGS
THERE IS NO LAW.
GALATIANS
5:22-23

## GALATIANS 5:25

———

A cartographer doesn't just sit at home and read guide books or examine photographs. She doesn't simply call up an old friend who has visited the place she plans to map, or write letters asking locals to pen their best descriptions.

She packs her bags, laces up her boots, calibrates her instruments, and travels there herself. She trudges along the muddy banks of the river and sketches the meandering way it slips across the landscape. She scrambles over boulders and high up stony mountains, where she peers over the valley, recording careful measurements of elevation and distance.

Christianity isn't just something to read about in books or hear about in church. It's not a list of rules or a map of some far-away land we'll never see or experience for ourselves. A faith like that would be constricting and dreary—but our faith is not that. The Spirit has given us new life so we can follow Christ into the new and exciting places he calls us to explore.

—Tyler Smith

IF WE LIVE BY THE SPIRIT, LET US ALSO WALK BY THE SPIRIT.

GALATIANS 5:25

## GALATIANS 6:9

Planting a seed is always fascinating. You bury it in the soil, give it water and sunlight, tend to it each day ... and wait. You wait and check and wait some more. This is the hardest part for me. I keep a close eye on that seed it until a small sprout finally shows itself because, once it comes through, it produces something beautiful.

We also plant seeds in our lives and wait to see the fruits they bear. We want to see results, and it's easy to give up when they aren't immediate. What's more important, we can't expect to reap the rewards on our own schedule. Sometimes we want to give up all too soon when we're not the ones in control.

But if we can refrain from growing weary, our good works will be worthwhile in the end because we've been assured by the one who provides the true reward: Jesus Christ.

—*Pam Bauthues*

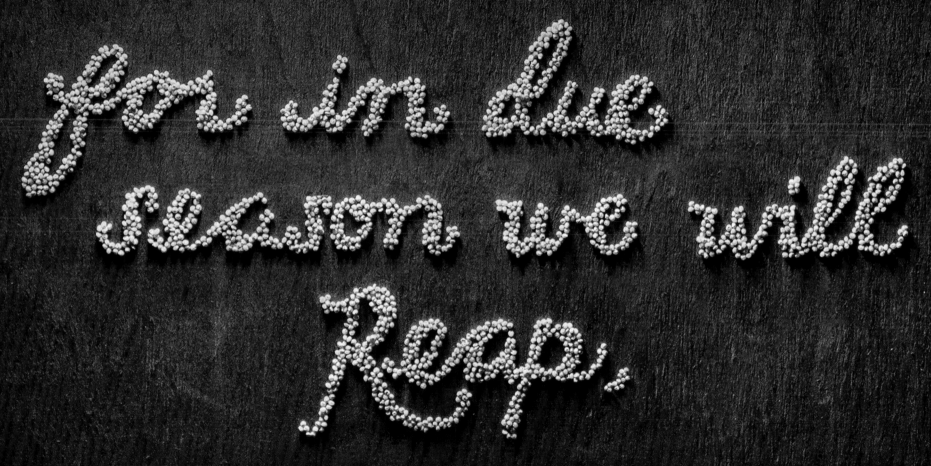

And let us not grow weary of doing good,

*for in due season we will Reap,*

if we do not give up. –Galatians 6:9

## EPHESIANS 1:7

────────

Jesus is the ultimate abolitionist. He gave his life to make millions of his estranged children free.

To him it didn't matter that we were enslaved by our own choices. It didn't matter that we betrayed him. It didn't matter that we murdered him for daring to show us a better way to live.

He bought the freedom of his murderers with his own blood and invites them—us—to revel in the riches of his grace. He gives only good gifts to his betrayers, and he does it joyfully, eagerly, and without prejudice.

—*Ray Deck III*

In him we have

*redemption*
*through* his blood

the forgiveness of our trespasses,

according to the riches of his grace

**EPHESIANS 1:7**

# PHILIPPIANS 1:21

---

This verse changed my life.

During my college years, I spent summers serving as a camp counselor. My first summer was incredible and life changing, but also extremely difficult. Working and living at a camp for three months straight meant that I had to give up a lot of what I wanted to do. Beyond that, I became a mediator to groups of fighting girls—an expert persuading them that camp food was actually delicious and cheesy games were fun, a shoulder to cry on when girls missed their parents at 3 a.m.

All summer, Philippians 1:21 was my go-to verse. And God let this verse sink into my mind and work in my heart. My desires became his, leading me to die to my wants and gain new insight into God's all-consuming love. I lived for Christ, and he gave me strength.

Finding life in Christ requires that you commit yourself to God daily. This commitment is one of the most amazing and empowering decisions you can ever choose to make.

—*Katie Monsma*

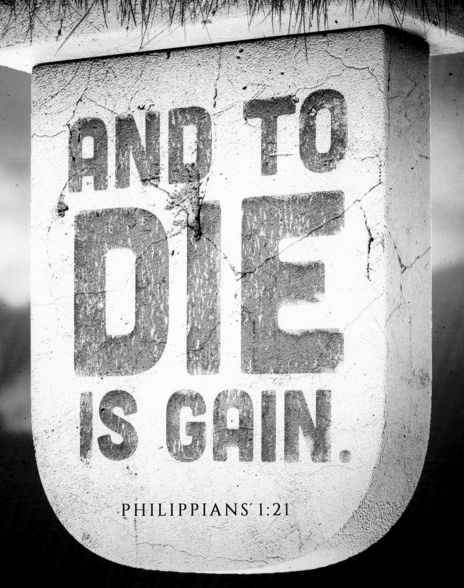

FOR TO ME
TO LIVE IS
CHRIST,

AND TO DIE IS GAIN.

PHILIPPIANS 1:21

# PHILIPPIANS 3:8

My heroes are people who have positioned themselves in the midst of suffering—in Christ's name. They dumpster-dive with the hungry, they farm the abandoned places, they create art amidst brokenness, they set up house in slums. They get as close as they can to people and places in the earth that are weeping.

They inspire me to persist in my struggle to faithfully balance so many complexities: self-care and self-denial, vulnerability and boundaries, safety and risk, giving and receiving. How do I protect and provide for my family while risking everything to be where Christ calls me, near the pain in the world? How do I rejoice at a table full of good food and wine without forgetting my Christian call to address my neighbor's need?

These conflicts boil down to the ultimate tension of the Christian life: Death leads to life leads to death leads to life. Loss and suffering seem to unlock the door to the ultimate treasure.

Dare I join my heroes and step nearer to the suffering ones who teach me how to gain Christ?

—*Carrie Sinclair Wolcott*

**Indeed, I count everything as loss because of the surpassing worth of knowing Christ Jesus my Lord.**

For his sake I have suffered the loss of all things and count them as rubbish, in order that I may gain Christ....

PHILIPPIANS 3:8

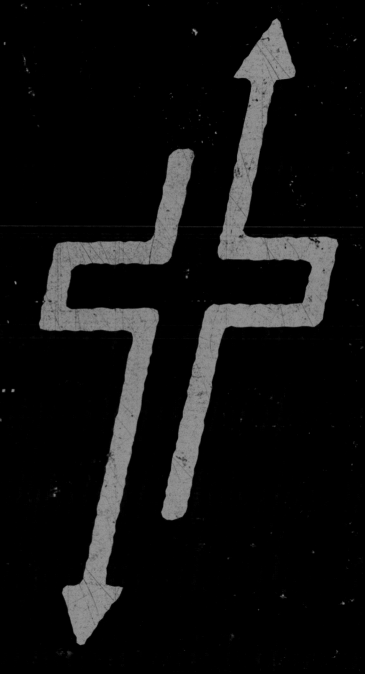

## PHILIPPIANS 4:11

———

Paul's words here are an encouragement to us all to follow his example of contentment, even though most of us will never face the kind of hardships he did during his life of service to God. Elsewhere in Scripture, Paul lists his many trials and sufferings for the sake of the gospel, including shipwrecks, beatings, and imprisonment.

In my comfortable day-to-day life, I so often feel dissatisfied—believing that a second car, a bigger house, and a newer mobile device will make me happy. In the winter I long for the brightness of spring, but spring is rainier and muddier than I remember, and suddenly only summer will do. The heat of summer lasts too long, and only the crispness of fall will make me content. But want only begets want. Paul demonstrates here that our true satisfaction cannot be found in possessions or comforts, but in Christ alone.

—*Jessi Strong*

NOT THAT I AM SPEAKING OF BEING IN NEED,
FOR I HAVE LEARNED IN WHATEVER SITUATION

*I am to be content.*

PHILIPPIANS 4:11

## COLOSSIANS 2:6

This artwork has two meanings for me, both of which can be described in one word: home.

First, the imagery. The background shows a mossy forest with an abundance of evergreen trees and ferns. I've grown up in the Pacific Northwest, so there is no better picture than this one to represent my home.

And second, the verse. My walk with Christ began when I was a kid. I learned about Jesus not only growing up in the church, but also around the dinner table at home with my family. Because of both these influences, I officially accepted Christ in my life when I was in high school. Leading up to that decision, though, I actually took many reflective walks through parks with woods just like you see in the picture.

There's just nothing better than connecting with the Lord in the heart of his very creation. To this day, exploring his vast and wonderful creation is still how I feel closest to my Lord and Savior.

—*Lauren Visser*

Therefore, as you received Christ Jesus the Lord, so

# WALK IN HIM

Colossians 2:6

# 1 THESSALONIANS 5:6

I love nightfall. When the sun drops below the horizon, I'm free. Phone calls, emails, and urgent questions finally come to an end. The world grows dark and silent, the streets empty, and grand possibilities await me. But more often than not, I squander my nightly freedom. I find myself pulled into the comfort of movies and episodes I've already seen. The Internet leads me down foolish paths with nothing worthwhile at the end of them. I watch my evenings quickly tick away. And while it's not literal, these distractions seem like a kind of drunkenness. I rob myself of creative opportunity for a conscious sleep—one that doesn't even grant me rest. I'd much rather live in a place of wakeful soberness.

The good news is every night starts fresh. I can live my dreams instead of watching them on a screen. I can spend my time conversing deeply with friends and loved ones. I can ponder the beautiful mysteries of God and life. Consciousness is a gift, and I'm not going to waste it.

—*Justin Marr*

SO THEN LET US NOT SLEEP, AS OTHERS DO, BUT

# let us keep awake and be sober.

1 THESSALONIANS 5:6

# 1 THESSALONIANS 5:11

———

Look around you: Who do you surround yourself with? Some say you're the sum of the five people closest to you. But spending time with people is a two-way street, and companionship provides opportunities for us to influence each other's lives.

We can worship God by caring for those around us; it pleases him and can bring us joy as well. It's also a necessary component of worshiping through community: If we're surrounding ourselves with other encouraging believers, we'll build one another up and become stronger together.

In community, we fit together like bricks in a building, and encouragement is the cement that holds everything together. Without it, the structure collapses, and we're left with just a pile of bricks. We're commanded to build each other up, and when we do, we create a safe haven to grow in Christ and invite others to meet him.

—*Pam Bauthues*

THEREFORE ENCOURAGE ONE ANOTHER AND

BUILD ONE ANOTHER UP, JUST AS YOU ARE DOING.

1 Thessalonians 5:11

# 1 THESSALONIANS 5:17

My default mode is self-navigation. "Everything is fine here, God, all under control. I'll call you if I need you, but until I hit a real problem, I should be just fine." I admit this is a crash-and-burn approach—and it always ends with me turning desperately to him when I realize how needy I really am.

The challenge to live a life of unceasing prayer seems equally doomed to failure. Thankfully, though, Paul isn't challenging me to a cloistered existence. He's prodding me to rely on God in a moment-to-moment way, not just the low points. I'm thanking him for all the good things he's given me—and maybe all the challenges, too. I'm asking him for direction before acting. I'm trusting in his goodness to me.

God is not a God for my out-of-control moments. He is the God who is always sustaining me, even when I don't realize it.

*—Rebecca Van Noord*

## 2 TIMOTHY 2:3-4

---

You don't have to look far to find people who are mocked and even persecuted for their faith. I think many people misuse the word persecution or misunderstand the cause of their suffering. This passage doesn't ask us to qualify or quantify suffering before we share in it. The more broadly we define suffering and interpret our call to share it, the closer we are to reflecting Christ, who suffered for all.

But sharing in suffering doesn't mean we are to be entangled in the world—we are not of the world. Our battle is greater. Our lives are more than jobs, homes, and cars. Our bodies are more than dust—they are for Christ's service.

Good soldiers know their mission and what it takes to accomplish it. Our mission is love, and our means is sacrifice—suffering for others, with others, on behalf of others. Share in suffering—not for the sake of suffering—but because you are part of the mission.

—*Ryan Nelson*

Share in **suffering** as a *good soldier* of **Christ** **Jesus.**

*No soldier gets entangled in civilian pursuits, since his aim is to please the one who enlisted him.* 2 Timothy 2:3–4

## HEBREWS 9:12

———

The priests of Israel entered the holy of holies once a year with the blood of an innocent animal. They would sprinkle the blood on the ark—the symbol of God's presence—and that blood covered the sin of the people of Israel, atoned for them, fulfilling the covenant for another year.

When God came to earth and took on human form, he offered himself as the ultimate sacrifice. In his dying breath, Jesus entered the holy place and with his own blood made payment for the sins of all people—a new covenant in his blood.

Once for all.

—*Ray Deck III*

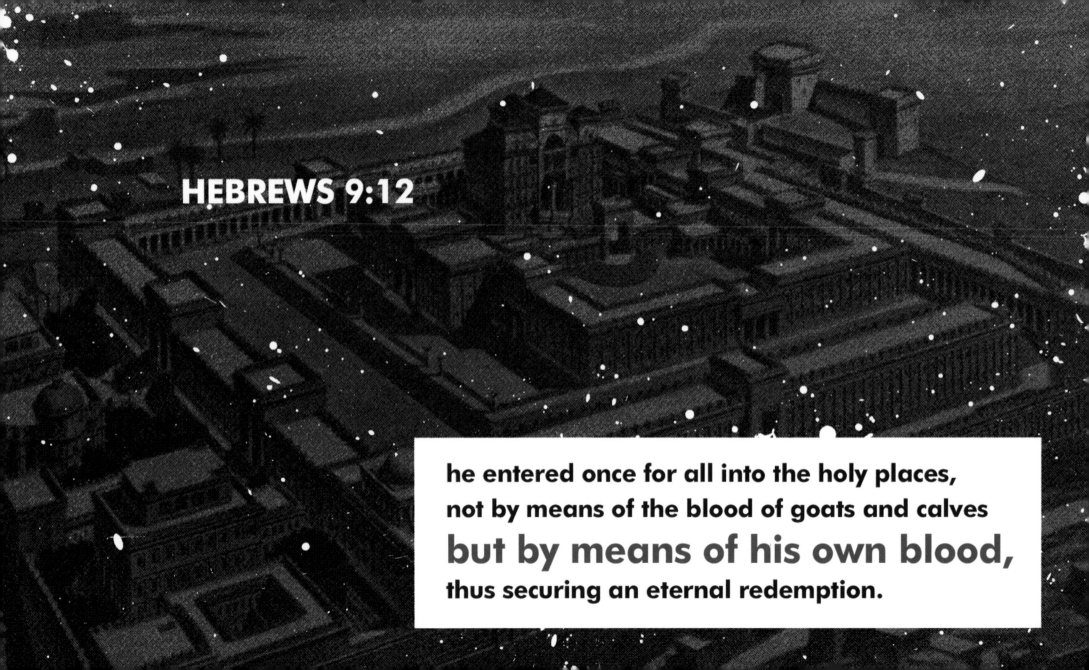

HEBREWS 9:12

he entered once for all into the holy places,
not by means of the blood of goats and calves
but by means of his own blood,
thus securing an eternal redemption.

# HEBREWS 9:22

In middle school I saw a therapist for Obsessive-Compulsive Disorder. I battled with it for years and still do today. Back then, one of my biggest obsessions was blood. I was terrified of it, but it wasn't a squeamish sort of fear. It was about disease and contamination. I thought every red spot I saw was a drop of HIV or hepatitis. I thought if I touched it, then I could contract it and unknowingly pass it on to the people I cared about. It wasn't logical, but that's OCD for you.

But when I became a Christian, I started to read about blood as a source of purification—both under the law and through Christ's sacrifice. I read about the Last Supper and taking part in communion. It was an intense shift in perception, but it made sense. Blood is a source of life much more than an avenue for disease. Suddenly blood took on a whole new meaning. It's funny how much Scripture can turn your view of the world upside down.

*—Justin Marr*

Indeed, under the law almost everything is

# PURIFIED WITH BLOOD

and without the shedding of blood
there is no forgiveness of sins.

**HEBREWS 9:22**

## HEBREWS 10:10

———

Day after day, year after year, the Israelites sacrificed animals in a futile attempt to cleanse themselves. Such sacrifices served as a symbol, but they could never take away sin.

Then Jesus came into the world, and he did away with the sacrificial system. By offering himself as the final perfect sacrifice, he made salvation freely available, once for all.

We who are in Christ share in his death. When Jesus allowed himself to be placed on the cross, he took our sins on himself, and he carried them into the grave. When he died, our sins died with him. In this way, Jesus freed us from sin. It no longer has power over us.

But Jesus did not stay dead—God raised him back to life! And because we share in Christ's death, we also share in his life. So when Jesus freed us from the power of sin, he also freed us from its penalty of death. We now live in the life of the crucified and risen King.

—*Chuck McKnight*

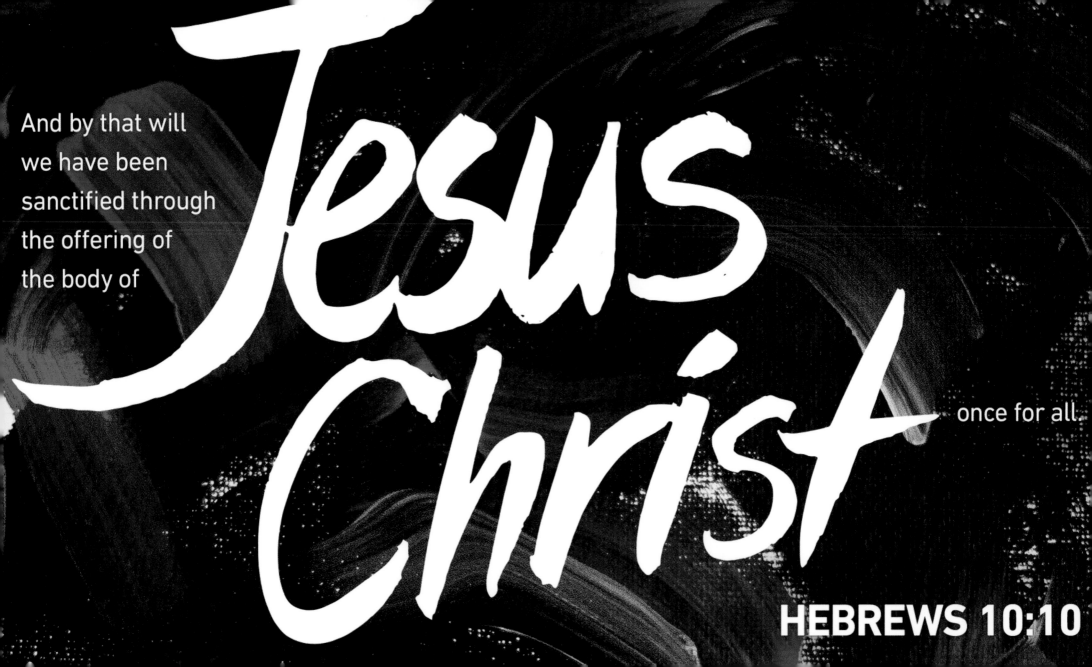

And by that will we have been sanctified through the offering of the body of *Jesus Christ* once for all

HEBREWS 10:10

# HEBREWS 13:8

He's the same yesterday, today, and evermore. And that's encouraging to know. Jesus isn't going to stop mediating between God and me. Jesus' sacrifice never expires. Jesus doesn't become obsolete or out-of-date (like the fresh fruit going bad in my fridge even though I planned to eat healthy this week).

But Jesus' lack of change does pose a problem. I'm supposed to become more like the Lord Jesus Christ. That requires a lot of change because I'm nothing like him.

Jesus is entirely unchanging, so I need to undergo massive change to be like him. But the more like Jesus I become ... the less I'll change, right?

Christlikeness must be the best plateau ever.

—Jeffrey Kranz

# JAMES 2:23

From a young age, I was taught about God's magnificence. He is present everywhere. He is all knowing. He is all powerful. These were good things to learn, and I had faith that they were true. Looking back, however, the way I processed those concepts painted an awesome but skewed view of God.

He's present everywhere. He's probably too busy for me. He's all knowing. He's aware of all the shameful things I try to hide. He's going to drop the hammer on me because of my sin.

Not someone I want to hang out with.

Then I found out that there is another, very important aspect of God that I was missing—he's my friend. A good friend has time for you, supports you in your struggles, and works toward reconciliation, not condemnation.

I am not just a nameless human that he moved from the "lost" to "found" column. I am cared for by the Creator of the universe on a personal level.

I want to hang out with that guy.

—*Jim LePage*

...and the Scripture was fulfilled that says,

**Abraham believed God, and it was counted to him as righteousness**

—and he was called a friend of God.

**James 2:23**

# JAMES 3:7-8

When I read these verses, I immediately think of that familiar schoolyard rhyme, "Sticks and stones may break my bones, but words will never hurt me."

The harsh reality is that words can wound us like razors, cutting deep into our hearts. Whether it's a bully's taunt or a callous remark by a coworker, words can exact a toll on us. Yes, sticks and stones may break our bones, but words can break our hearts.

You see, there's a deep connection between the feelings of the heart and the words of our mouth. Our innermost feelings find a way to be vocalized, whether we mean it or not. Jesus tells us to love our enemy as our self. Until we truly believe that in our heart, we risk falling into the trap of gossip, slander, and insult.

I pray that Jesus would help us turn our words from razors into a healing salve—restoring hearts and healing wounds.

—*Jake Mailhot*

## JAMES 3:17

———

Usually when I think I have an exceptionally good idea or plan, I'll argue for it. My assertion is sincere—I believe in my idea—but it's probably not impartial. It's likely peaceable since I am a people-pleaser, but it's probably not open to reason since I don't like being told I'm wrong. And if it's gentle, it's probably in the most passive-aggressive way possible.

For these reasons, my own wisdom fails, a lot. James reminds us to examine wisdom to see if it is balanced and brings peace, purity, and good fruits. And even if we don't understand "wisdom from above" at first, the pieces come together if we take a look around. Creation, in all of its unique and ordered glory, reflects this kind of wisdom. Sometimes I need to take time enjoying nature to realize how small my own plans are in comparison to our Creator's. Only then, with a humble heart, can I submit my own thoughts to the scrutiny of heavenly wisdom.

—*Lynnea Fraser*

but the wisdom from above is first pure, then peaceable, gentle, open to reason, full of mercy & good fruits, impartial & sincere.

james 3:17

# JAMES 4:14

At first glance, this verse seems kind of cruel. God reminds me that I'm just a little blip in the history of time and that before I know it, my life will be over? Thanks for the pep talk, God. You'd make a terrible life coach.

But after some reflection, I started to realize the verse may actually be communicating something else. Yes, my life is a blip in time, but there's an aspect to that that's incredibly liberating. I feel like God is saying, "Your life is short, so live each day like it's your last. Love, serve, and show radical grace like you'll never have another opportunity!"

All of a sudden, it makes life seem like such a precious gift. Every second of every day is an opportunity for me to advance the kingdom of God. What would it look like to live life from that mindset?

Spoiler alert: It looks like Jesus.

—Jim LePage

*…yet you do not know what tomorrow will bring. What is your life? For you are a mist that appears for a little time and then*

# VANISH

JAMES 4:14

# 1 PETER 2:24

––––––––

One of my doctors arranged for his pastor to hold a healing service for those of us with cancer and other serious conditions. We gathered that night for prayer and anointing, for encouragement in recounting God's faithfulness to his promises.

When the pastor came to speak with me, he thought I must be in shock. How could I be so steady in the midst of crisis? He didn't understand when I said there's a difference between being cured and being healed.

We're all broken and in need of healing, regardless of our health. I was at peace because even if the doctors couldn't cure my cancer, Jesus had already healed me when I put my faith in him decades earlier.

By Jesus' wounds—the sacrifice of his body on the tree—we are healed from the sickness of sin and death. If not in this world, then in the world to come. Bless the Lord, O my soul.

—*Rebecca Brant*

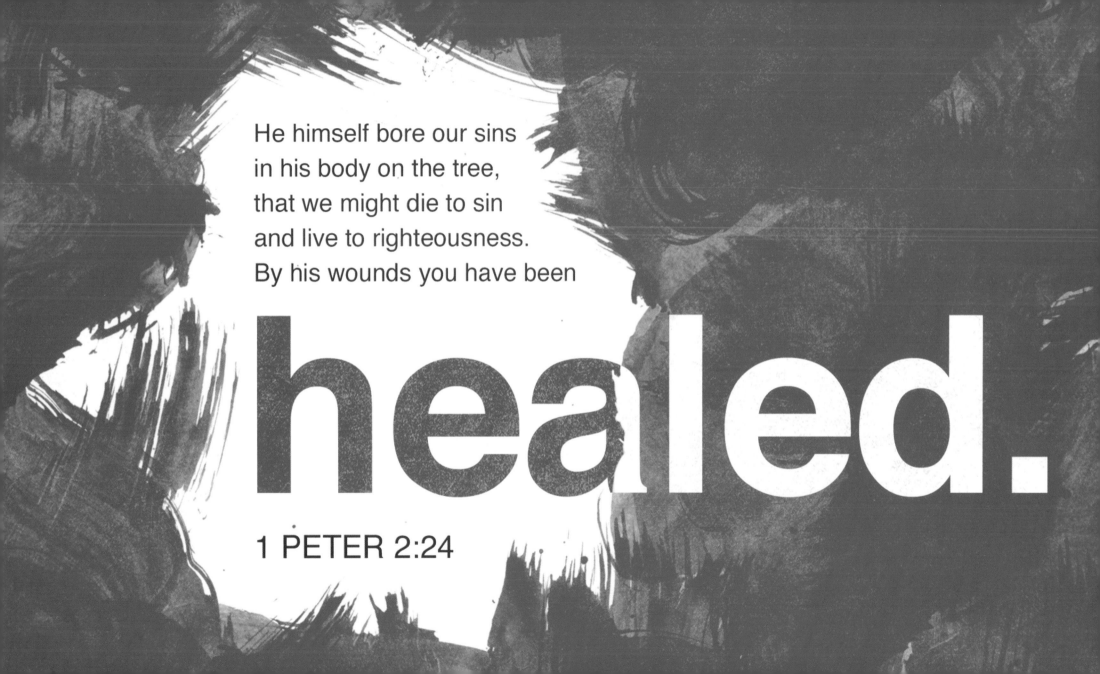

He himself bore our sins in his body on the tree, that we might die to sin and live to righteousness. By his wounds you have been

healed.

1 PETER 2:24

# 1 PETER 5:7

"We found something" was not what I wanted to hear after a nerve-wracking evening in the ER for vision loss. There I was, 20 years old and diagnosed with a brain tumor.

As I lay in bed that night, waiting for the full prognosis at my appointment the next morning, I had two choices: freak out, or leave it in God's hands. I did a little of both. But let me tell you: I didn't gain anything from the freak-out moments—except to learn that I needed to stop, calm down, and trust.

I was very fortunate throughout the process, and I came out of surgery with a great outlook. Most important, I learned that whether our anxieties are big or small, casting them on God is the most peace-giving, reassuring thing we can do. Make a habit of trusting him before freaking out. He cares for you deeply.

—*Tayler Beede*

. . . casting all your **anxieties** on him, because he cares for you.

1 Peter 5:7

# 1 PETER 5:8

─────

Every day we're bombarded by things vying for our attention. Even our best attempts to focus on the things that matter are drowned out by the cacophony surrounding us, a roar as loud as a lion.

As we become distracted by this noise, we become passive consumers of the world around us. We devour all the entertainment we can get our fingers on, and in turn, our souls become numb and withered.

To be devoted to the kingdom means to be actively engaged with the world around us. Immerse yourself in the Word so that it will be imprinted on your heart. Be thoughtful. Be on guard. Stand firm in your faith, and know that Jesus will restore, confirm, strengthen, and establish you.

*—Jake Mailhot*

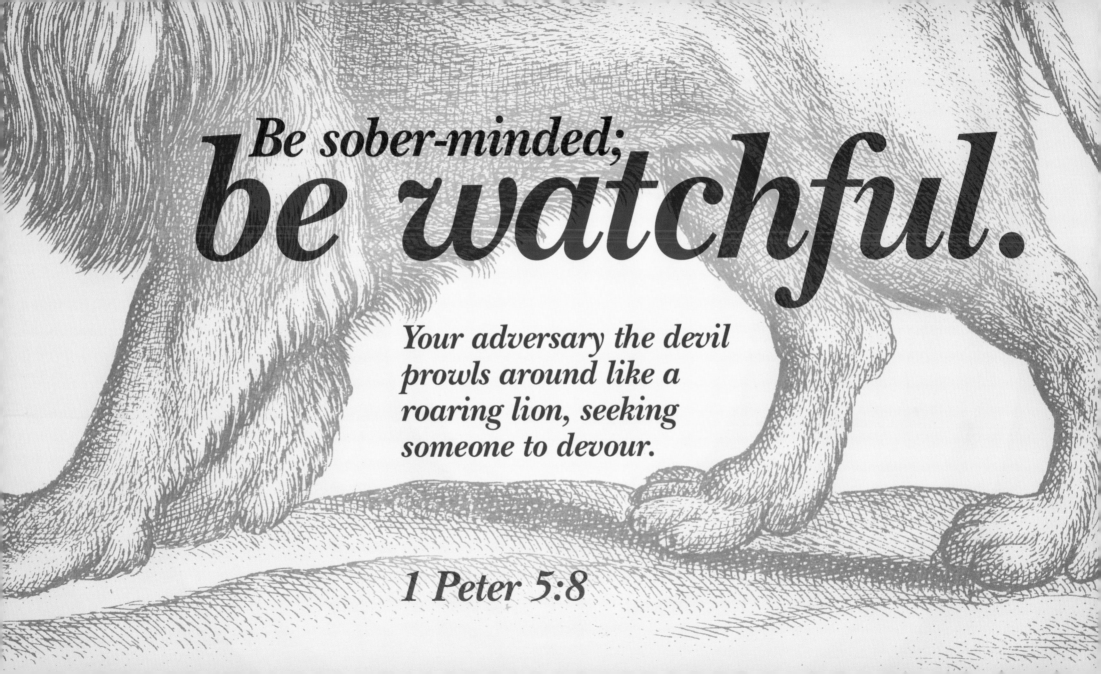

# 1 JOHN 1:2

Putting together a jigsaw puzzle is slow and tedious work. But as an image emerges from the pile of disconnected fragments, excitement grows and momentum builds. When you place the final piece, you see at last what was there from the very beginning.

As an old man, John wrote of something he had learned about Jesus long before. He put it together from pieces he picked up along the way—the tender compassion shown to a suffering woman; a quiet display of power on a raucous sea; a soul-rending episode of grief followed by inexplicable and unrelenting joy.

John put the final piece in place and saw that Jesus was life—the eternal life that was with the Father from the beginning. Once that truth was revealed to him, John painted a picture so others could experience the same exhilaration of discovering who was there all along.

*—Tyler Smith*

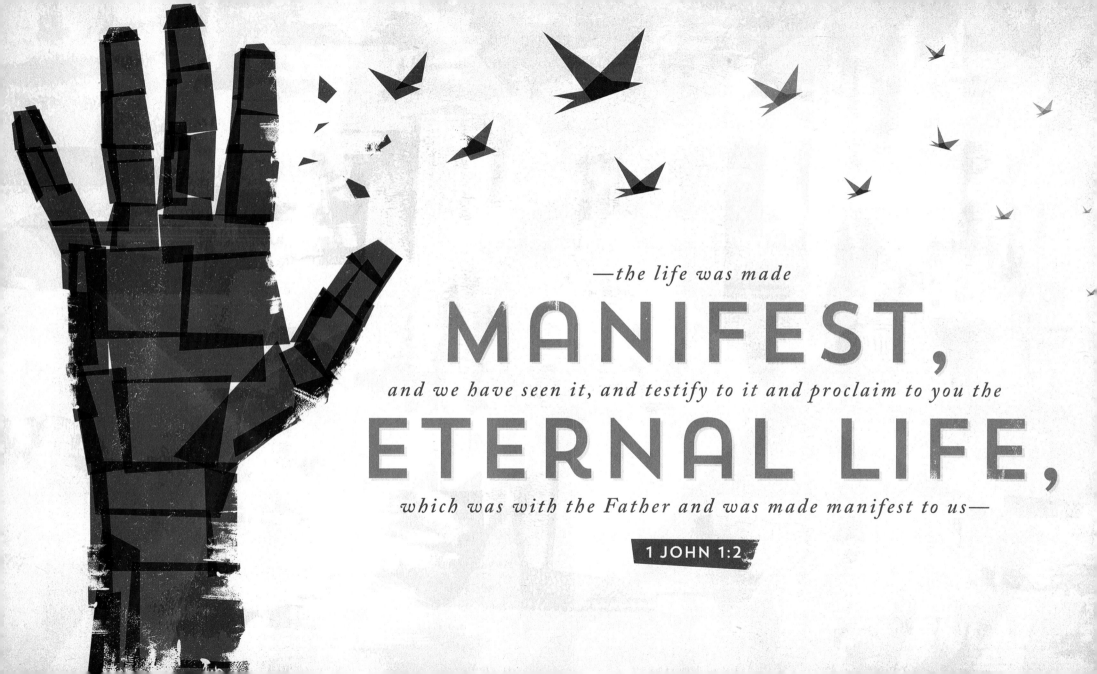

—*the life was made*

# MANIFEST,

*and we have seen it, and testify to it and proclaim to you the*

# ETERNAL LIFE,

*which was with the Father and was made manifest to us—*

1 JOHN 1:2

# 1 JOHN 4:8

God is love. Could there be a more profound statement in all of theology?

John does not simply say that God is loving. We already know that love is one of God's attributes. Rather, John says that God actually *is* love. Love is the very essence of God's being. Love defines who God is and what he is like. Every attribute that is true of God—whether it be his holiness, his mercy, or his wrath—is a subset of the truth that God is love.

But what is love? Is it an emotion? A desire? A feeling of endearment or good will? Thankfully, we don't have to guess at its meaning. While John says that love defines God, he also says that Jesus defines love. The ultimate expression of love is found in Jesus, hanging on the cross, dying for his enemies.

Love is sacrifice. Love is the giving of oneself for the sake of others. This is the love that defines God. And as his children, we too must show this love.

—*Chuck McKnight*

# GOD IS LOVE

1 JOHN 4:8

# 1 JOHN 4:19

Jesus tells us that the two greatest commandments are to love God completely and love others selflessly (Mark 12:30–31). But where does that love come from? How are we supposed to figure out what loving God and others looks like? Who set the example?

Jesus showed us who God is (John 14:7). Jesus showed us what love is (1 John 4:8). Then he showed us what love does (4:10).

Because God loves us, we can love him. And God has poured out so much love on his children that we can't help but pass that love on to one another (4:11).

God loves us into loving him, and loves us into loving others. He gives us the great commandments and then empowers us to obey.

—*Jeffrey Kranz*

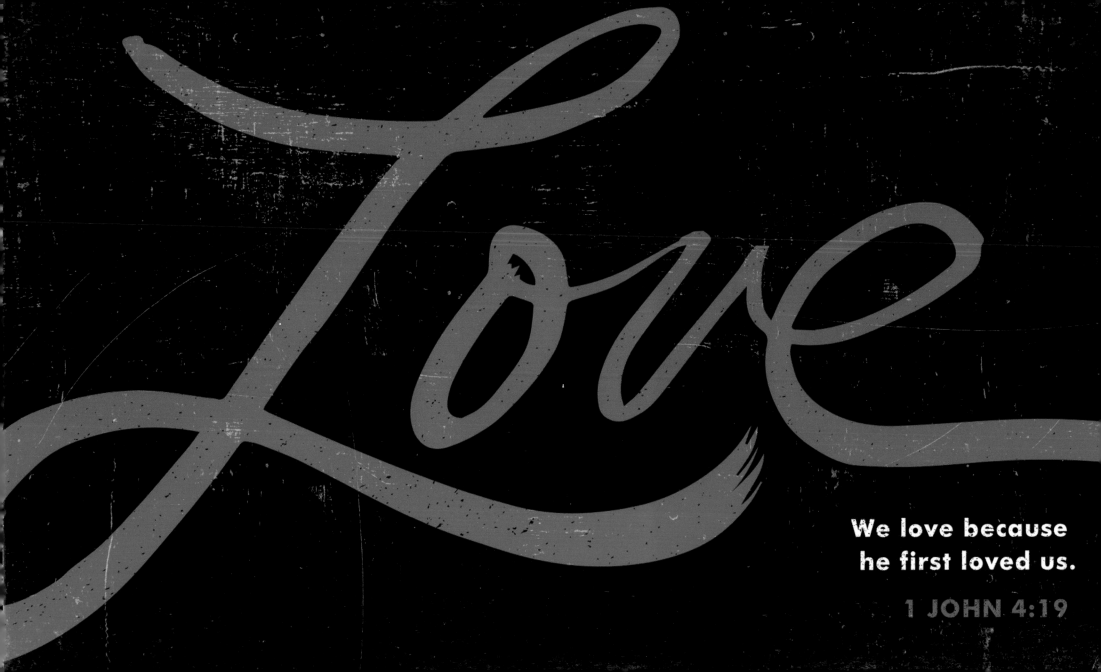

Love

We love because
he first loved us.

1 JOHN 4:19

# 1 JOHN 5:4

---

Temptation is everywhere. For many of us, life can simply be a series of trials in which we try to tamp down our hate, quell our anger, and subdue our jealousy. And even while we're not fighting wars within ourselves, we're fighting them against other people or other countries.

But remember: The real battle isn't won through us. It's already been won by Jesus. He overcame the world when he died, rose again, and ascended to heaven. He is the ultimate conqueror, and by believing in him and putting our faith in his Word, we follow the only one who leads us to true victory.

So while it may feel like the mountain before you is unclimbable or the hurdle too high, know that with faith in God, you will be victorious.

—*Sherri Huleatt*

For everyone who has been born of
God overcomes the world. And this is
the victory that has overcome the world—

# OUR FAITH

1 John 5:4

# REVELATION 5:5

In his death and resurrection, Jesus defeated death for all eternity. He is the conqueror who brings restoration in his wake, not destruction. He promises eternal life for those who call him Lord. The war has already been won!

Yet, that victory is "now, but not yet." As victors with Christ, how are we to act in the here and now, where the battle still rages?

Take courage. The conquering King strides alongside us. Walk with the quiet confidence of a lion. Do not boast in our victory. Instead, call others to join in Christ's victory over sin and death.

The kingdom is here and the kingdom is coming! Aslan is on the move.

—*Jake Mailhot*

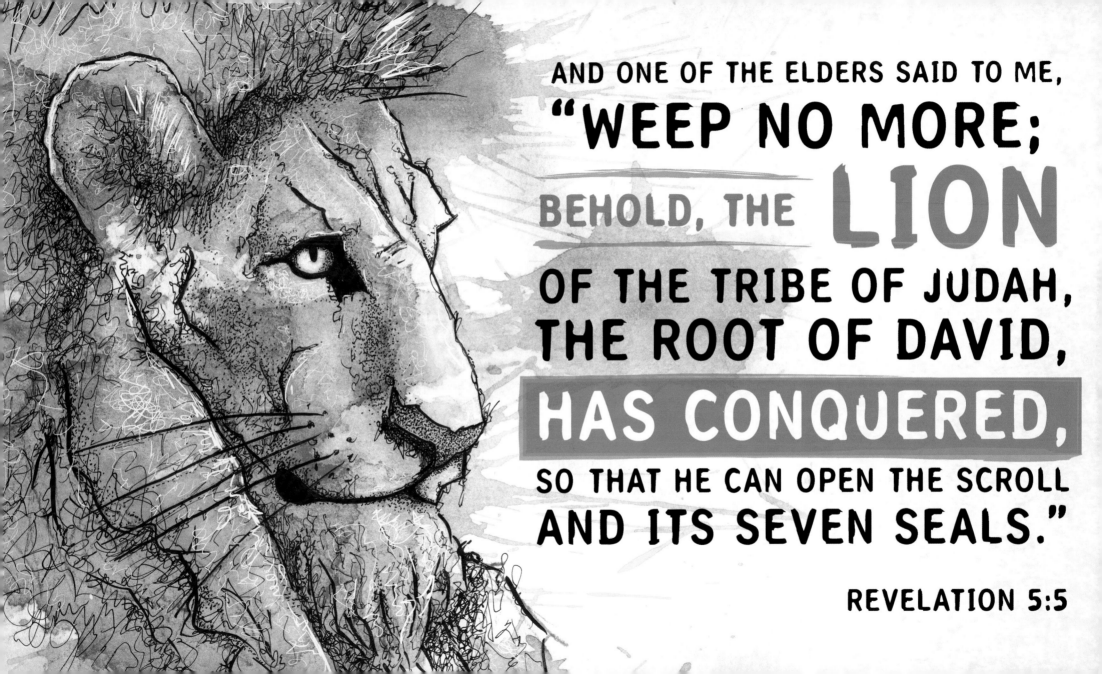

AND ONE OF THE ELDERS SAID TO ME, "WEEP NO MORE; BEHOLD, THE LION OF THE TRIBE OF JUDAH, THE ROOT OF DAVID, HAS CONQUERED, SO THAT HE CAN OPEN THE SCROLL AND ITS SEVEN SEALS."

REVELATION 5:5

# REVELATION 7:17

Our Lord was ridiculed, persecuted, tortured, and crucified. So why do we expect anything different as his followers?

In Revelation, those who stand before their Shepherd in their white robes are identified as those "coming from the great tribulation." We can only imagine how stained and tattered their robes were before being washed clean in the blood of Jesus' sacrifice. But can we imagine those people as us?

We face trials and tribulations of all sorts. We may not have known poverty or hunger in our own lives, but they're not so far removed from us as we might think. We endure debilitating illness, betrayal, and shunning for our faith. We face financial crises, broken relationships, the loss of loved ones we know we'll see again—and ones we know we will not. By some counts, we face nothing compared to our brothers and sisters being martyred for their belief.

When we stand with the multitude before the throne, the Lord will wipe away each tear we have wept in our suffering. I pray that the hope of that day will embolden us to face tribulations with faith, to stand strong, to proclaim the name of Jesus, no matter the cost.

—Rebecca Brant

# ARTISTS

**ANDREW BERKEMEYER** is a designer and illustrator living in the Pacific Northwest. He has a passion for all things creative, and loves music, sports, and enjoying life with friends and family.

*Art on page 21*

VIBRANTIMPACT.COM

**BRANSON ANDERSON** is an artist and designer in Bellingham, Washington. He seeks to create art full of beauty and truth for God's pleasure.

*Art on pages 27, 89, 111, 117, 123, 135, 171, 205*

**CHRISTINE GERHART** is an art director and designer with a love for coffee, exploring new places, and designing book covers. Hailing from Omaha, Nebraska, Christine has traveled and worked in beautiful places such as New Zealand, Uganda, and India before making her way to the Pacific Northwest.

*Art on pages 79, 139, 151, 153, 161*

CHRISTINEGERHART.COM

**CORBIN WATKINS** is a designer and illustrator with a love for midcentury modern design and children's picture books. He runs his own letterpress shop in Bellingham, Washington, where he lives with his wife, Alli, their son, Ulysses, and their dog, Eleanor Roosevelt.

*Art on pages 103, 145*

VVPRINTSHOP.COM

**FRED SPRINKLE** is a Pacific Northwest motion graphic designer and lettering enthusiast. He lived on a sailboat for his first 18 years.

*Art on page 121*

FREDSPRINKLE.COM

**JAKE ROBERTSON** is a designer who lives with his wife in the Pacific Northwest.

*Art on pages 11, 125, 191*

YELLOWXBLUE.COM

**JIM LEPAGE** is a freelance artist and designer. He founded Biblestock.co, which sells digital Bible art, and he cocreated and curates Old & New, a collaborative Bible design project. He is the #1 search result on Google for "Bible reading idiot."

*Art on pages 9, 23 (with Sean Fields), 25, 33, 35, 37, 45, 47, 53, 55, 59, 65, 73, 85, 87, 93, 99, 105, 113, 129, 133, 137, 149, 155 (with Quintin Cooke), 159, 173, 175, 177 (with Quintin Cooke), 179, 181, 187, 189, 193, 197, 199 (with Quintin Cooke), 201*

JIMLEPAGE.COM

**JON DEVINY** is an illustrator and designer hailing from Spokane, Washington. By day he does art direction for video games, but he spends his nights in the studio screen-printing and creating art. He finds constant encouragement and inspiration with his wife and son.

*Art on pages 43, 71, 83, 107, 203*

JONDEVINY.COM

**JOSH WARREN** is a freelance designer and Illustrator. He is leader to his pack of three dogs.

*Art on pages 13, 15, 29, 51, 61, 101, 109, 147, 163, 167, 185, 195*

JOSHWARRENDESIGN.COM

**KAYLA SOPER** is a graphic designer and family photographer who lives with her husband in the beautiful Pacific Northwest.

*Art on pages 63, 75, 95, 131*

KIN.PHOTOGRAPHY

**LIZ DONOVAN** is a bespectacled, black coffee–guzzling designer who tells stories in pixels or on paper. When she's not in front of a computer or wielding an exacto, you can likely find her tinkering with her bike or tromping around some mountains somewhere.

*Art on pages 49, 81, 91*

**LYNDSEY PLUTE** is a designer who finds inspiration from being outside and drinking a good cup of coffee. In her off time, you may find her unicycling, playing piano, beat boxing, or all three.

*Art on pages 67, 69*

LYNDSEYPLUTE.COM

**MICAH ELLIS** is design director at Faithlife. He is passionate about design and its special ability to poignantly tell the truth in a variety of contexts and platforms.

*Art on page 119*

BEHANCE.NET/MICAHELLIS

**QUINTIN COOKE** is a dad, cupcake maker, and art director from Salt Lake City, Utah. You'll find him at the beach with his girls in Southern California.

*Art on pages 143, 155 (with Jim LePage), 165, 177 (with Jim LePage), 183, 199 (with Jim LePage)*

QUINTINCOOKE.COM

**SHILOH HUBBARD** has been a designer for most of his life—professionally for 8 years. He's obsessed with minimalism, pixels, and a midcentury modern design aesthetic.

*Art on pages 7, 17, 39*

**MAX MORIN** designs and plays music inspired by the fresh scent of rain on evergreen and concrete in the majestic Pacific Northwest. Any day that includes ping pong, eggs Benedict, or a fresh dose of Holy Spirit is a grand day in his book.

*Art on pages 57, 127*

MAXDMORIN.COM

**RONALD RABIDEAU** is an animator and illustrator at Faithlife. He occasionally enjoys chicken and waffles.

*Art on pages 41, 169*

RONALDRABIDEAU.COM

**PATRICK FORE** has been in involved in full-time design for more than 10 years, serving mainly in the local church. He serves as graphic designer at Faithlife in Bellingham, Washington.

*Art on pages 19, 31, 97, 115, 141, 157*

PATRICKFORE.DESIGN

**SEAN FIELDS** is a father, son, husband, designer, photographer, illustrator, builder, adventurer, and Bellinghamster.

*Art on pages 23 (with Jim LePage), 77*

SEANFIELDS.COM

# WRITERS

**AARON ARMSTRONG** is an author and speaker based in London, Ontario.

*Writing on page 116*

BLOGGINGTHEOLOGICALLY.COM

**ABBY SALINGER** is an avid hiker and reader. She lives in beautiful Bellingham, Washington.

*Writings on pages 22, 62, 68, 90*

**ABIGAIL STOCKER** is a Midwestern transplant to the Pacific Northwest. When she's not editing books and magazines, you'll find her biking, dreaming of British libraries, and seeking small adventures in everyday life.

*Writings on pages 36, 44, 80, 140*

**BRANDON RAPPUHN** is a product coordinator for Faithlife. When he's not designing new products, he's hanging out with his high school youth group, brewing beer, or reading some Catholic spirituality book.

*Writings on pages 14, 50, 86, 92*

**CARRIE SINCLAIR WOLCOTT** holds a master of arts in theological studies from Regent College. She parents four sons with her husband, Zack.

*Writings on pages 52, 76, 114, 158*

**CHUCK MCKNIGHT** is a writer and blogger. He lives with his wife and two children in Bellingham, Washington, where he works as a marketer for Lexham Press.

*Writings on pages 94, 98, 176, 196*

BEINGFILLED.COM

**GWEN SMITH** is a speaker, worship leader, cofounder of the Girlfriends in God blog on Crosswalk.com, and author of *Broken into Beautiful*.

*Writing on page 58*

GWENSMITH.NET

**JAKE MAILHOT** is product manager for Lexham Press. He served as managing editor for DIY Bible Study and writes for LookoutLanding.com.

*Writings on pages 16, 124, 182, 192, 202*

JAKEMAILHOT.COM

**JEFFREY KRANZ** writes, designs, and consults at OverviewBible.com. He's committed to showing off the whole Bible for how interesting and applicable it is—and getting more people to study it themselves.

*Writings on pages 6, 12, 148, 178, 198*

OVERVIEWBIBLE.COM

**JESSI STRONG** is the senior writer for *Bible Study Magazine*. She lives in the Pacific Northwest.

*Writings on pages 8, 34, 38, 88, 102, 144, 146, 160*

JESSISTRONG.COM

**JIM LEPAGE** is a freelance artist and designer. He founded Biblestock.co, which sells digital Bible art, and he cocreated and curates Old & New, a collaborative Bible design project. He is the #1 search result on Google for "Bible reading idiot."

*Writings on pages 60, 84, 112, 180, 186*

JIMLEPAGE.COM

**JOEY COCHRAN** holds a ThM from Dallas Theological Seminary and is the pastoral assistant at Redeemer Fellowship in St. Charles, Illinois. He is the weekly resource reviewer for Lifeway's blog for pastors and contributes to many other websites.

*Writing on page 120*

JTCOCHRAN.COM

# WRITERS

---

**JUSTIN MARR** has written for Bible Study Magazine and SmallGroups.com. He is interested in bad weather, deep conversation, and independent comics.

*Writings on pages 56, 66, 164, 174*

THESOCIALHUNGER.COM

**KATIE MONSMA** is blessed to know good friends, great family, and an amazing Creator. She loves to explore new places and enjoy good company.

*Writings on pages 46, 48, 136, 156*

KATIEMONSMA.COM

**LAUREN VISSER** values time spent connecting with family and friends, appreciating the beauty of the Pacific Northwest, and practicing faith in daily life.

*Writings on pages 32, 106, 130, 162*

LAURENVISSER.COM

**LORE FERGUSON** is a writer whose deepest desire is to embody the gospel in everything she says and does. She lives in Fort Worth, Texas, and is a covenant member at the Village Church.

*Writing on page 100*

SAYABLE.NET

**LYNNEA FRASER** is an editor and a Pacific Northwest native. On any given Saturday, you'll find her baking cookies, hiking a new trail, or curling up with a good book. She dreams of owning a fox.

*Writings on pages 118, 126, 138, 184*

**MICHELLE LINDSEY** has been married for 23 years. She is the mother of six children and loves each season of parenting. She spends her time homeschooling and cowriting a marriage blog with her oldest daughter.

*Writing on page 20*

NITTYGRITTYLOVE.COM

**MIKE MOBLEY** seeks to glorify God in everything. He is in love with Jesus, his wife, Joelle, daughter, Petyon, and son, Matthew.

*Writing on page 14*

BEFORETHECROSS.COM

**PAM BAUTHUES** is a marketer, writer, and grammar enthusiast. A Bellingham, Washington, native, she enjoys exploring the Northwest and frequenting local coffee shops.

*Writings on pages 26, 134, 152, 166*

**PAMELA ROSE WILLIAMS** is a wife, mom, and grand mom. She and her pastor-husband serve at Selah Mountain Ministries in Albuquerque, New Mexico. She is a Christian freelance writer, editor, and web content manager. She enjoys bird-watching, gardening, crafting, technology, and blogging at ChristianityEveryDay.com.

*Writing on page 122*

**RACHEL WOJNAROWSKI** loves her husband and seven children more than life. A sought-after blogger, author, and speaker, she most enjoys caring for her busy family.

*Writing on page 74*

RACHELWOJO.COM

**RAY DECK III** founded the Skookum Kids organization, which cares for children in their first 72 hours of foster care.

*Writings on pages 72, 154, 172*

SKOOKUMKIDS.ORG

**REBECCA BRANT** is a bibliophile, wine connoisseur, and doting auntie. She works as an editor in Bellingham, Washington, and enjoys knitting, watching BBC, and spending time with friends. She belongs to a 12-year-old rescue cat and has a penchant for correcting typos on menus.

*Writings on pages 24, 28, 64, 142, 188, 204*

# WRITERS

———

**REBECCA VAN NOORD** is editor-in-chief of Bible Study Magazine and coauthor of *Connect the Testaments*. She enjoys good books, long hikes, and the company of friends.

*Writings on pages 18, 40, 128, 168*

**SHAUN TABATT** serves as a senior publicist for Bethany House and Chosen Books. He and his wife, Lynette, and their eight children make their home in Minnesota.

*Writings on pages 42, 78*

**TYLER SMITH** has written for newspapers, radio, and the web. He lives in the Pacific Northwest where he writes fiction and edits *LogosTalk*, the Logos Bible Software blog.

*Writings on pages 10, 70, 150, 194*

**RYAN NELSON** is a Young Life leader and writer in Bellingham, Washington. He writes regularly for the Faithlife blog.

*Writings on pages 54, 96, 132, 170*

**SHERRI HULEATT** is a copywriter, marketing strategist, and lover of puns. She is pursuing a master's degree in integrated marketing communications from West Virginia University. When she doesn't have her head in a book, you'll find her camping, eating tacos, or starting a dance party.

*Writings on pages 110, 200*

**RYAN J. PEMBERTON** studied theology at Oxford University and Duke Divinity School. His book on calling, *Called: My Journey to C. S. Lewis's House and Back Again*, released in February 2015.

*Writings on pages 82, 104*

**TAYLER BEEDE** is the marketing specialist for Bible Study Magazine. She likes writing, baking, and enjoying the beautiful Pacific Northwest.

*Writings on pages 30, 190*

NITTYGRITTYLOVE.COM

Bible Screen

Get Bible Art on All Your Screens

BibleScreen.com